FIGURE FANTASY

THE POP CULTURE PHOTOGRAPHY OF DANIEL PICARD

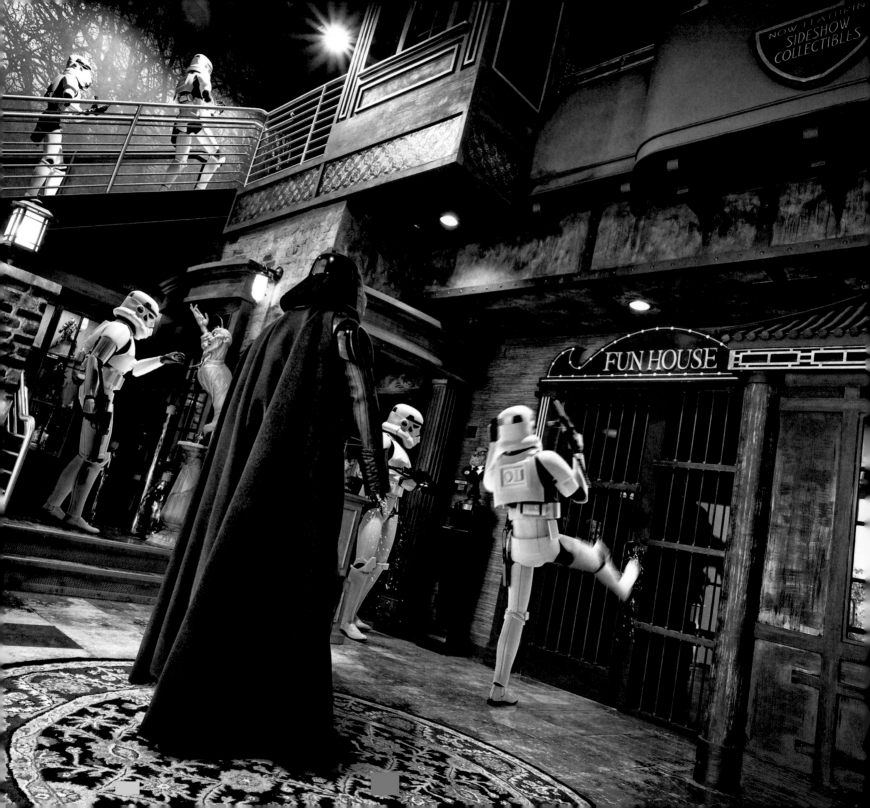

FIGURE FANTASY

THE POP CULTURE PHOTOGRAPHY OF DANIEL PICARD

FOREWORD BY

SIMON PEGG

INTRODUCTION BY

DANIEL PICARD

AFTERWORD BY

KEVIN SMITH

INSIGHT ◉ EDITIONS

San Rafael, California

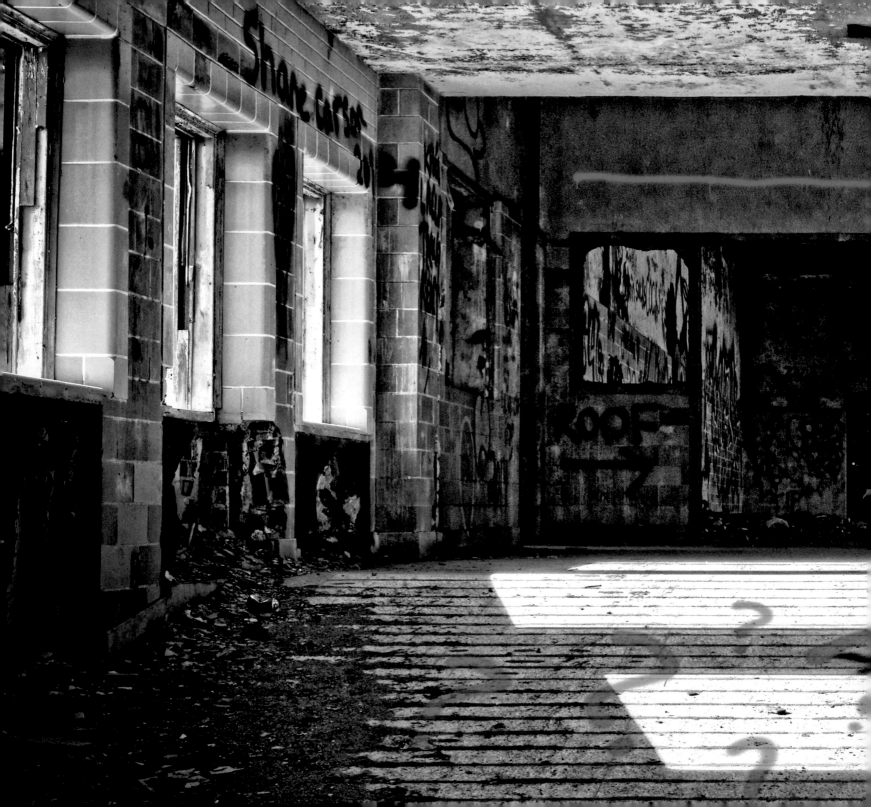

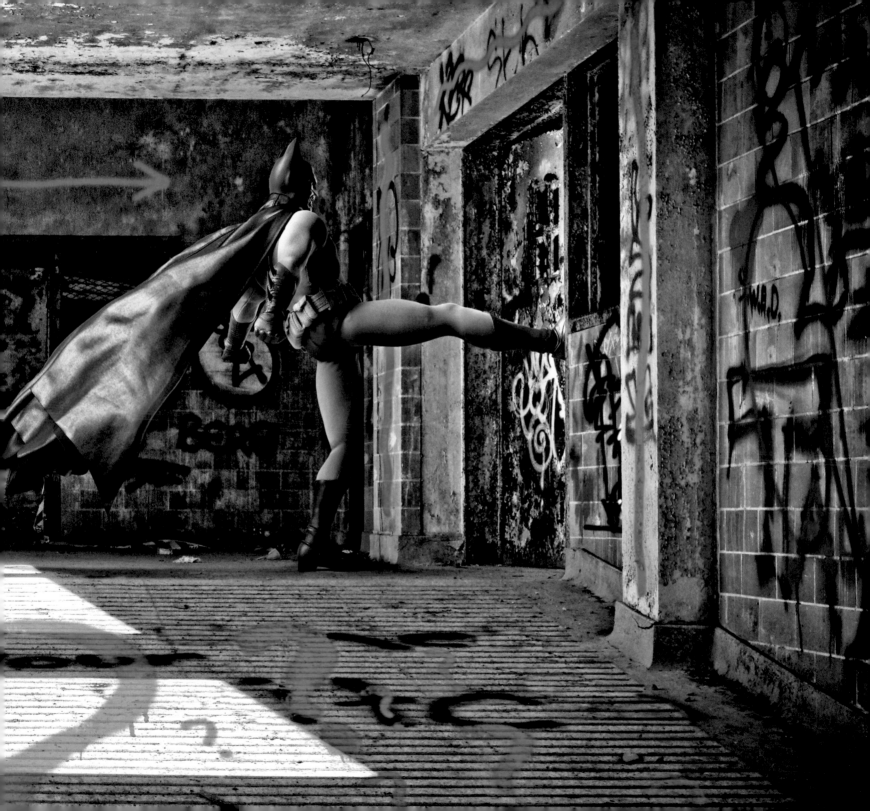

FOREWORD BY
SIMON PEGG

When I first came across this collection of witty photographs by Daniel Picard, I thought it was a wonderful conversation piece. I love the fact that once you take ownership of these fantasy characters and you purchase these collectibles, you are able to let your imagination run wild with them: These photos are the ultimate expression of that notion. Since the majority of collectors keep these beautifully crafted effigies carefully maintained and boxed, it's refreshing to see them out and about, doing things like cleaning their cars, shopping, and enjoying their leisure time.

As you observe the details of each picture, it's hard not to admire the sly humor and the amount of thought the photographer has given to each composition, whether it's in the images with the Snowtroopers or the one with the Joker looking at a Batman costume.

This clever book is a subtle reminder that these collectibles have also grown up with us through the years. The idea of collecting has gradually evolved with the people who began buying these toys around the time *Star Wars* came out in the late 1970s. Nowadays, there's a different approach to collecting: It has become more sacred and valued. That's why it is so great to see these toys played with in such a smart way. Each photograph is a cartoon, a joke, a whimsical thought. Images like the one with Superman in Malibu or the Clone Troopers visiting Legoland reveal so much, and they move smoothly from the sublime to the ridiculous. In a way, a sense of fun has returned to something that had become studious.

One of the main reasons these photos work so well is that they feature Sideshow figures, which are so detailed and lovingly crafted that they easily lend themselves to realistic settings. They fit right in as full-size beings in our world and allow us to experience a variety of emotions. For example, the photograph with Jango Fett and Boba Fett offers a nice little joke about fatherhood, while the one with Obi-Wan Kenobi waiting for Boba Fett delivers a wonderful kind of movie moment.

I was also struck by how quickly this collection took me back to when I was a seven-year-old boy and bought my first 99-pence Star Wars R2-D2 action figure in the UK. I recall the demand was so great and they ran out of the figures so quickly that they would sell the empty boxes and promise to send you the toy once it was back in stock. Years later I passed on my Star Wars toys to my daughter, and I love the fact that she takes them out of their boxes and plays with them every so often. That spirit of fun is inside these toys that we played with as children, and that is something that must not be forgotten.

A while back, I took my Sideshow *Shaun of the Dead* figure and put it next to a zombie schoolgirl figurine. I took a picture of the two of them holding hands as if they were on a date, and ran it with the caption, "If these two can make a go at it, then there's hope for the world." Dan's photos offer a sophisticated extension of that idea. The real message seems to be that it's important to play and have fun with these toys. This book reclaims that notion in a most wonderful way.

I hope these inspiring photos encourage readers to take their collectibles out of their boxes, to live in the moment, and to see what happens when you mix these worlds and genres. They celebrate the art of living in the moment, thinking outside the box, and delighting in witnessing a Star Wars Tusken Raider fighting Jason from *Friday the 13th*. How can you resist an invitation like that?

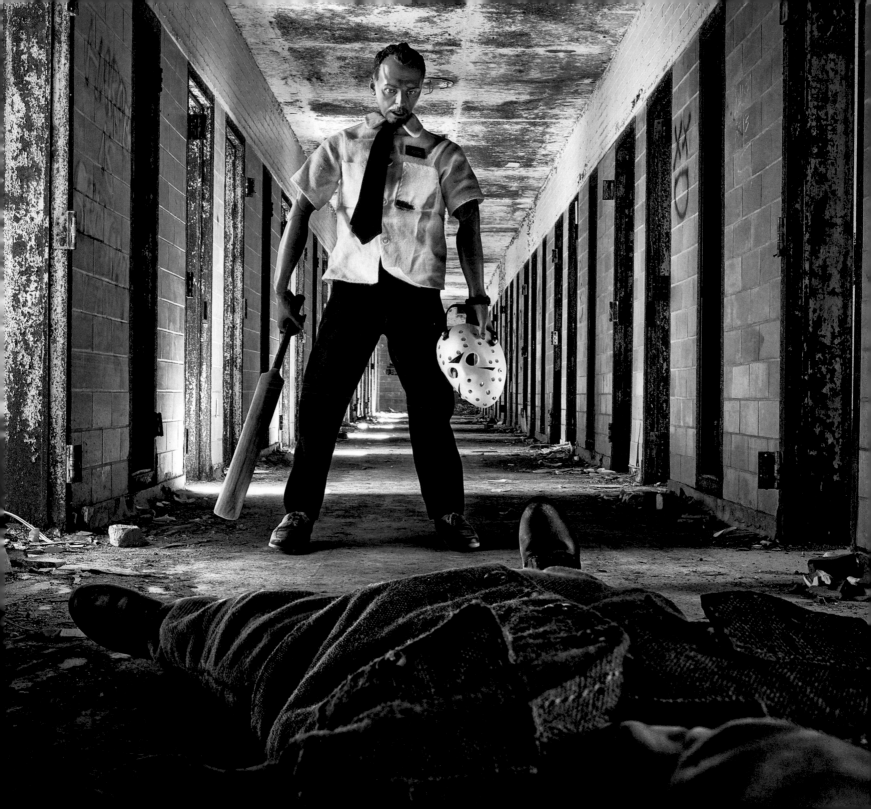

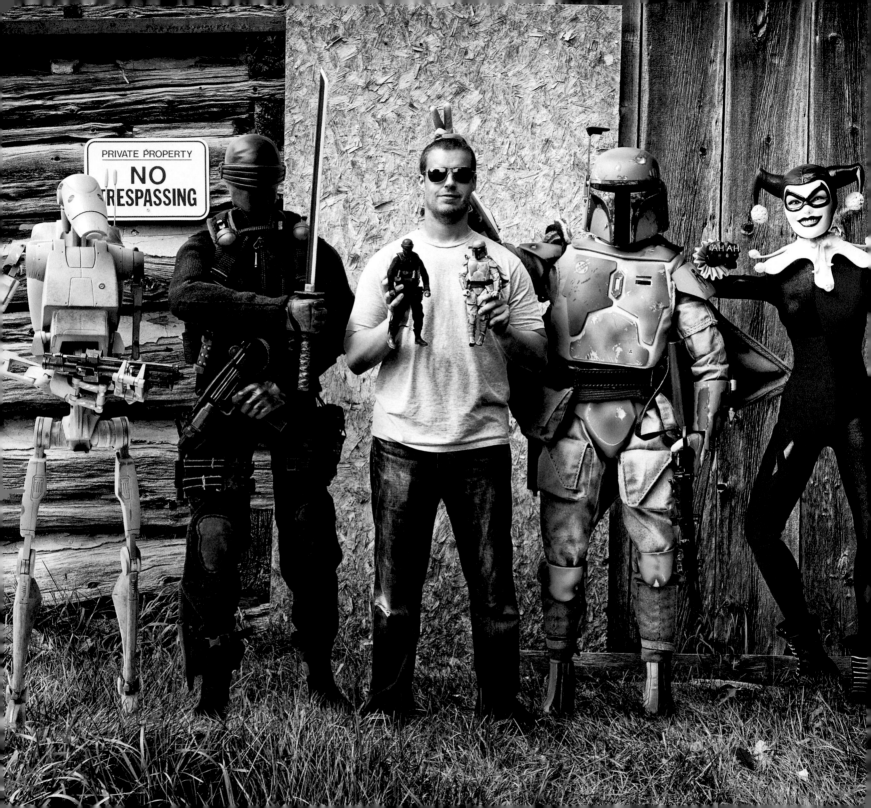

PRIVATE PROPERTY
NO
TRESPASSING

People often want to know how I came to use collectible figures in my photography. I guess my fascination with action figures began one Christmas when I was ten years old and received a few G.I. Joe 3-¾″ figures and vehicles. It was exciting to play with the same characters I knew from comic books and cartoons. Soon after that, my little ninjas and soldiers were introduced to other toys like Superman, Batman, and Star Wars characters, which got me interested in their movies and comics as well.

About five years ago, I came across a beautiful cornfield near Ottawa, not far from where I live. Because the road to this field was going to be shut down for construction, I had to improvise to take my photograph. I didn't have time to organize my "model in a fancy dress holding a balloon" scene, so I ended up using a small robot figure that I had just bought to decorate my office. It ended up making the photo even cooler than I had originally envisioned. I liked it so much that I knew this was something I had to explore further. While doing some research online to see what else I could use, I came across the Sideshow Collectibles website and discovered their Star Wars and G.I. Joe collections. Seeing my two favorite childhood toy series all grown up and turned into these very detailed and poseable figures gave me the idea of using them in my new photography project. I quickly realized that I had come to the right place.

After the first group of photos was warmly received online, I decided to push harder and learn how to photograph more complicated scenes indoors and outside. I was having so much fun throughout the process that it soon became clear to me that this mix of real-world photography and fantasy was going to become a major part of my life. My collection slowly grew as I tried to cast a diverse group of characters—heroes, villains, soldiers, robots, etc.—and focused on a variety of new stories that appealed to me.

I especially liked the idea of exploring what these characters do when they are not saving the world or fighting each other.

What makes these photos feel lifelike is the quality of the figures themselves. For the past twenty years, Sideshow has been producing this remarkable collection, and just from looking at my own figures, I can see how much the studio has evolved and perfected their art through the years. I couldn't pull off these photos if I were using 3-inch figures with little or no detail. I see these sixth scale, 12-inch figures as little humans—my own cosplay army that is always dressed up and ready to go. It has given me a lot of joy to invite viewers to come with me and imagine these figures to be at least six times bigger than they actually are. I spend hours at night just sketching and coming up with more ideas for new photos. That's my favorite part of the process.

In 2013, with maybe twenty finished photos in my series, I sent my favorites to the folks at Sideshow Collectibles. A few hours later, I got an email from the CEO of the company, Greg Anzalone. He told me that they loved my work and encouraged me to continue shooting their toys in these realistic settings. That game-changing email was the perfect confidence booster that I needed to turn my little hobby into something more serious, as well as the beginning of a wonderful relationship with an amazingly creative company.

I'm still that same kid with his toys who wanted to see the Joker face off with G.I. Joe or Star Wars characters interact with superheroes. Now that I'm older and know how to use a camera, photography has become my way of expressing these stories. I have many stories left to tell, and I'm so happy that I found the perfect outlet to share them with the world. I get to work with some of the amazing comic book and movie characters with which I grew up, and I love putting them in situations that make people smile. Thanks for coming along for the ride and seeing these fantasy figures through my eyes!

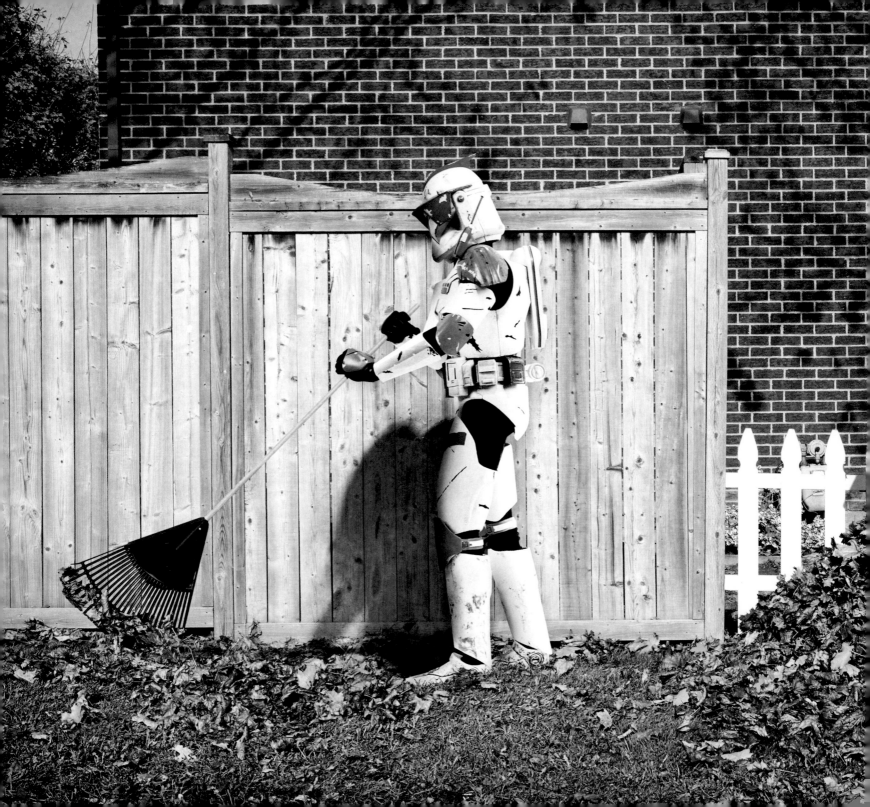

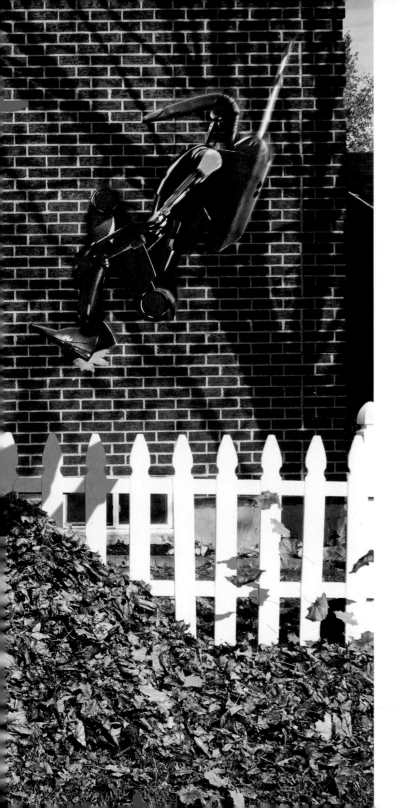

"I walk by this house six times a day. This photo was planned months ahead of time; I just needed to wait until there were enough leaves to make a giant pile. I see my Battle Droids as the most childish and immature characters in my collection, so the idea of having one do this jump came to me instantly. Making his Clone Trooper enemy angry for messing up his hard work was just a nice bonus."

A BATTLE DROID DIVES INTO A PILE OF LEAVES.

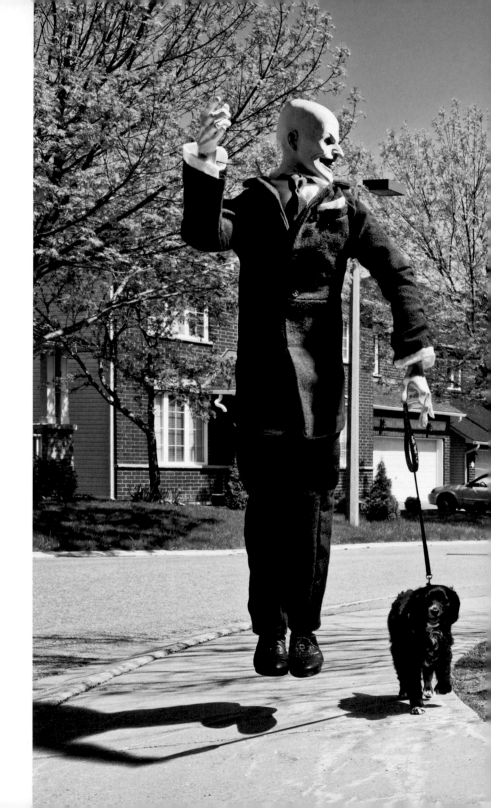

THE GENTLEMEN FROM *BUFFY THE VAMPIRE SLAYER*
WALKING THEIR DOGS ON AN ORDINARY DAY.

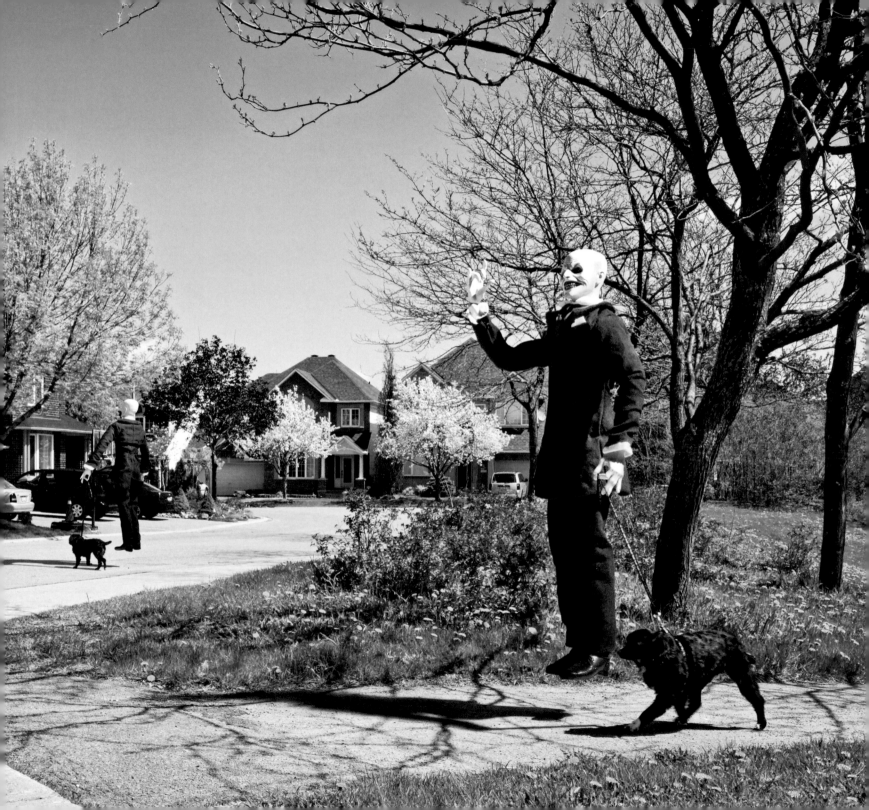

THE JOKER CHOOSING A HALLOWEEN COSTUME.

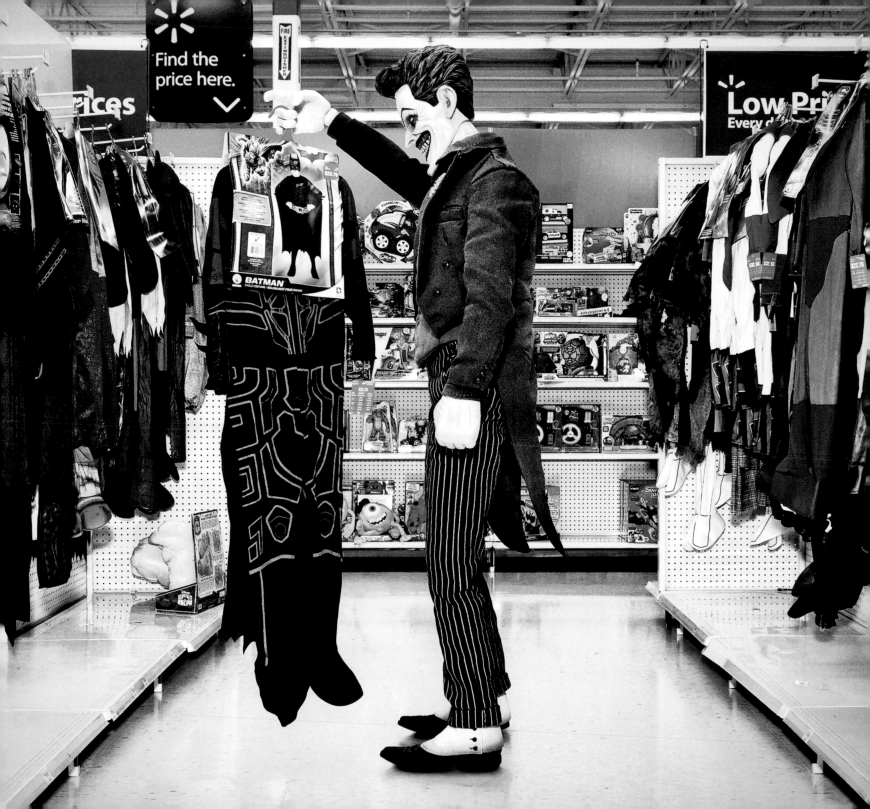

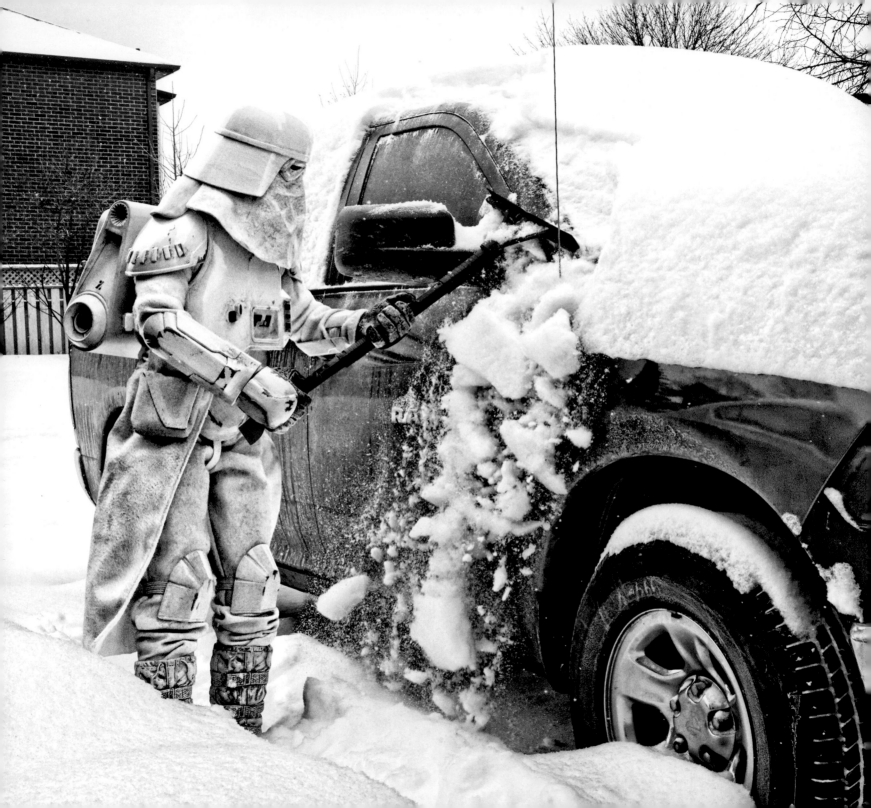

A SNOWTROOPER, PREPARING TO COMMUTE TO WORK,
CLEANS THE SNOW FROM HIS CAR AFTER A BLIZZARD.

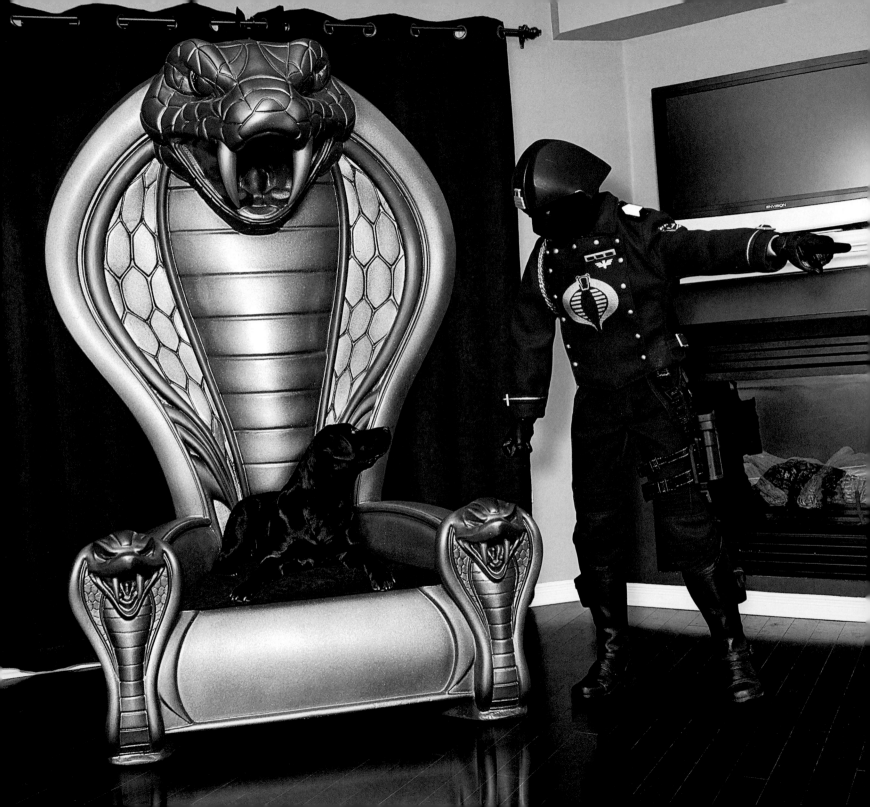

A COBRA CRIMSON GUARD ORDERS HIS DOG TO LEAVE COBRA
COMMANDER'S THRONE IMMEDIATELY.

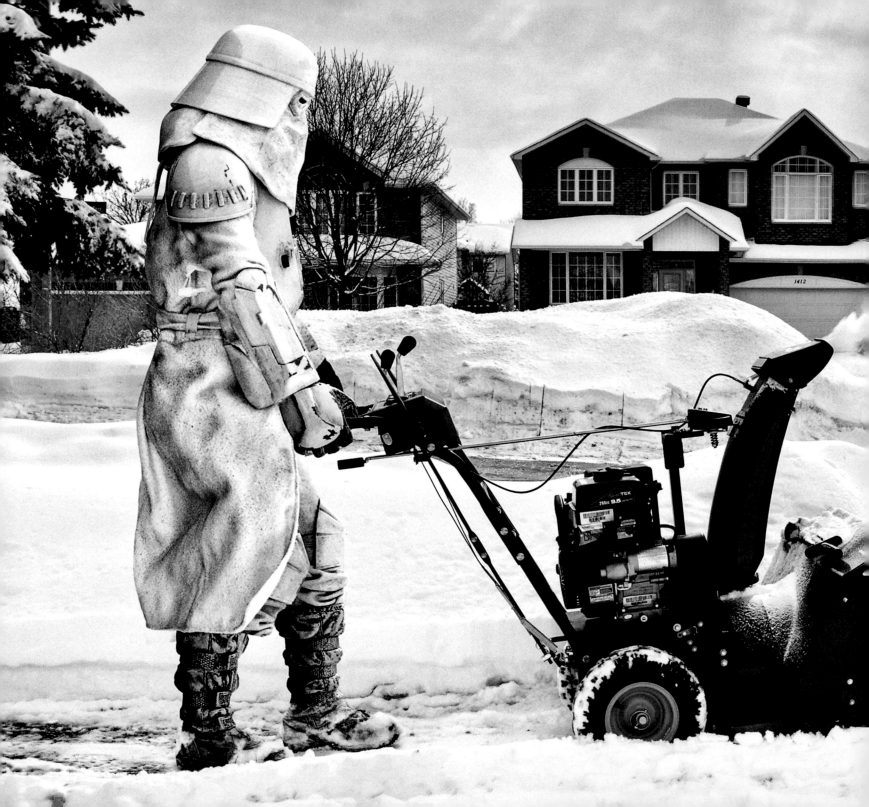

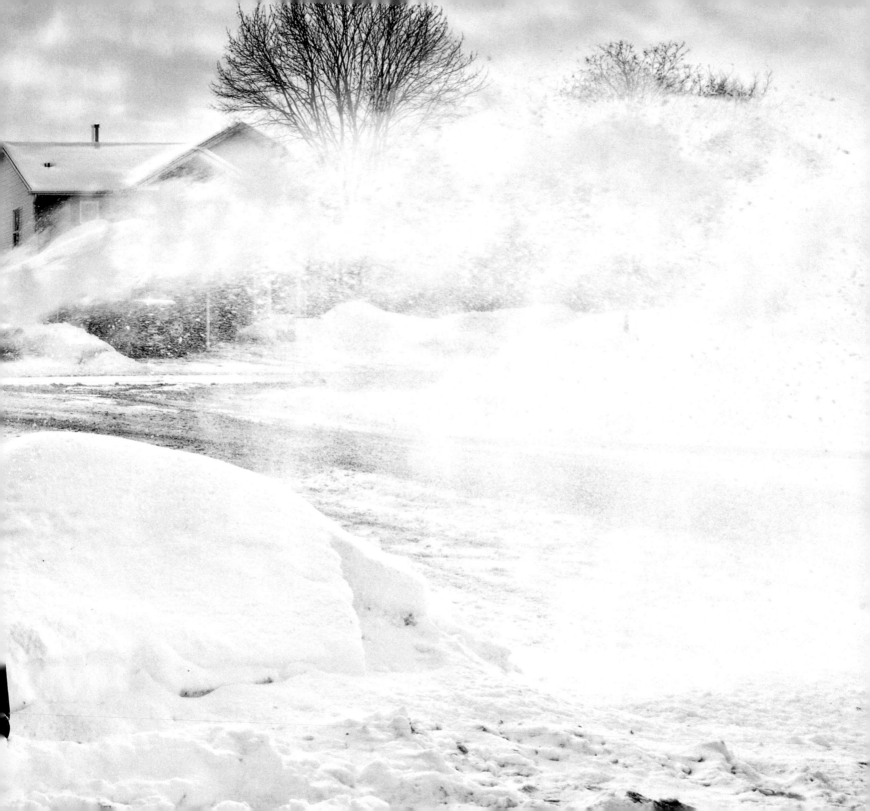

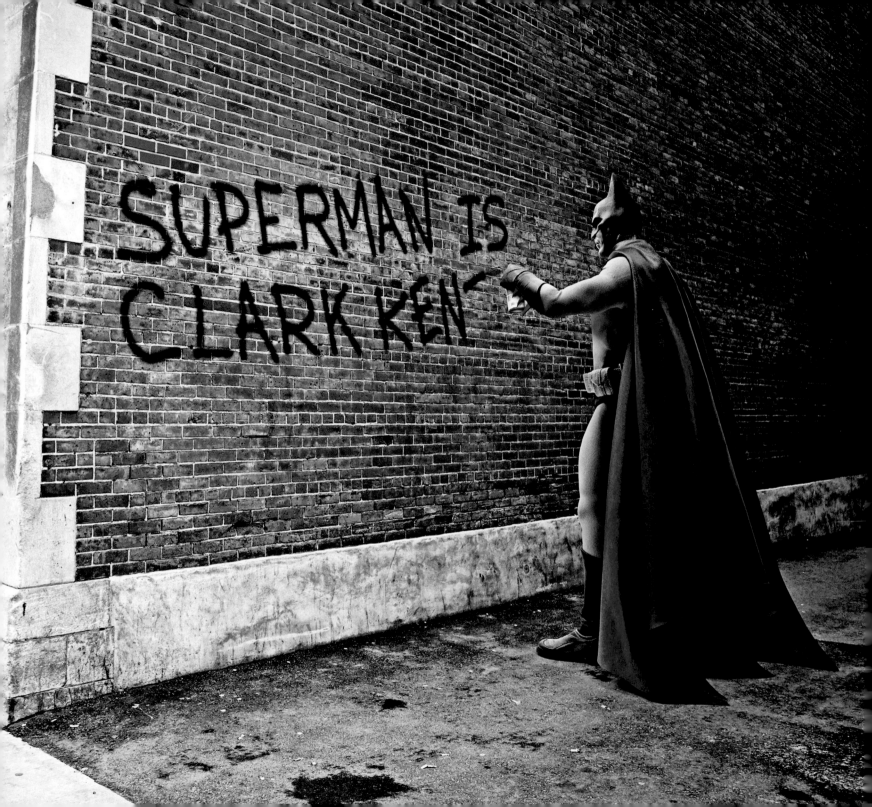

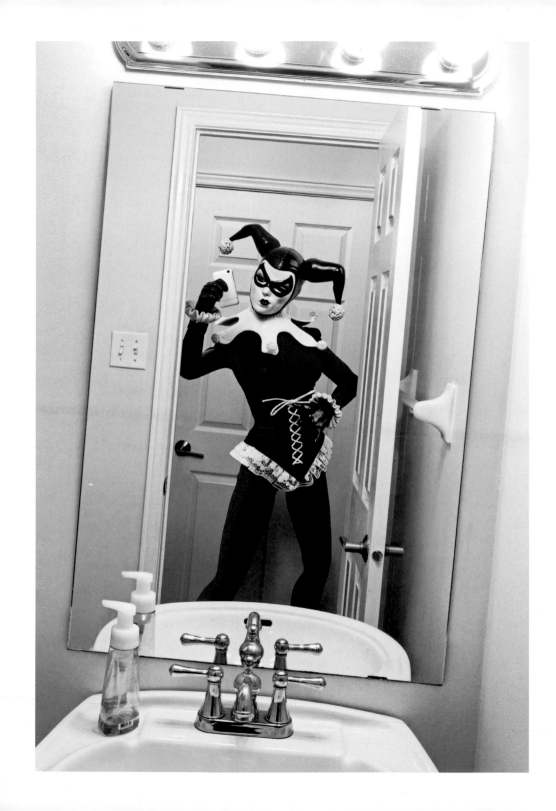

"Sometimes the inspiration for a photo comes straight from the look on a figure's face. This collectible of Harley Quinn, one of my favorite characters from the Batman universe, has a great smirk on her face that reminded me of the familiar 'duck face' selfie expression that we see on Facebook and Instagram."

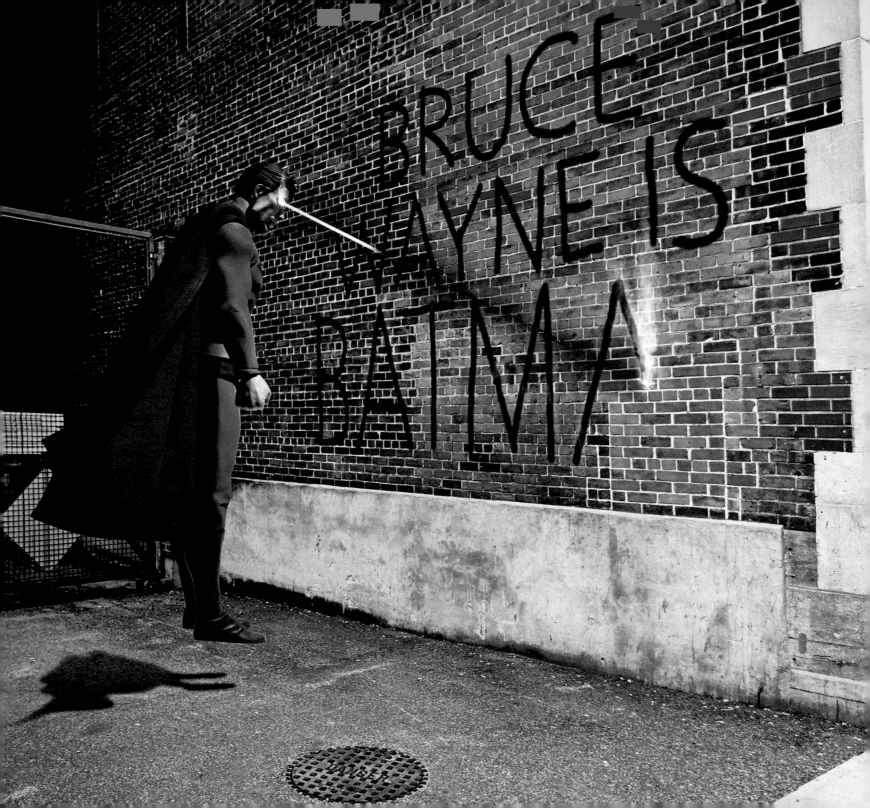

SUPERMAN REVEALS BATMAN'S SECRET IDENTITY.

THE JOKER TAKES A SELFIE AMONG A DISPLAY OF SUPERHERO
BUSTS AT THE SIDESHOW COLLECTIBLES STUDIO.

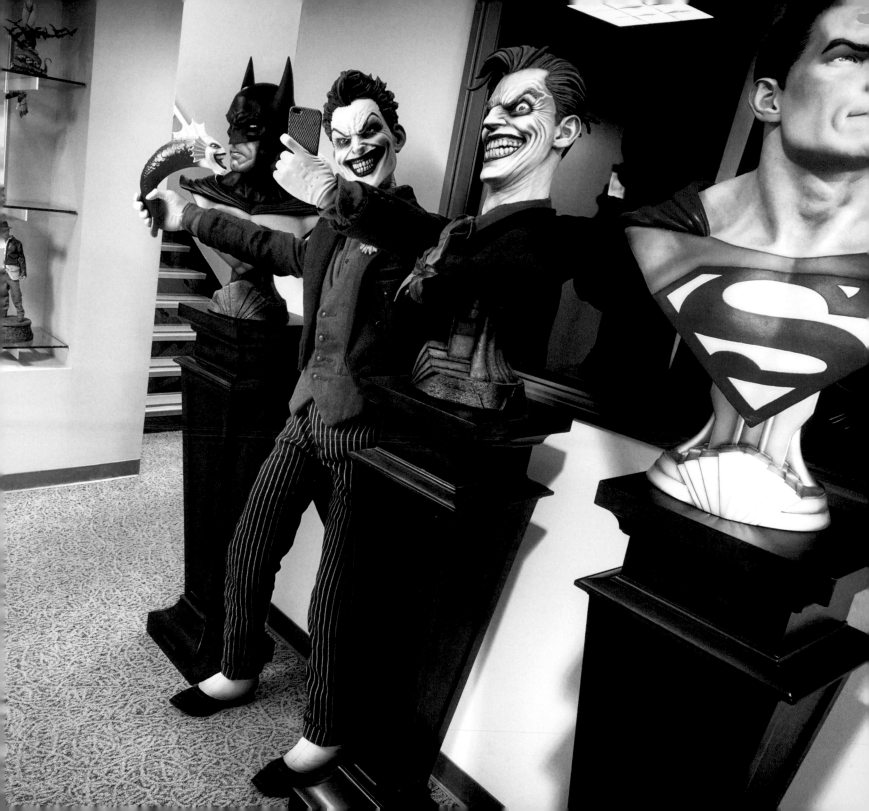

A BATTLE DROID ENJOYS A STAR WARS BOOK IN THE BATHROOM.

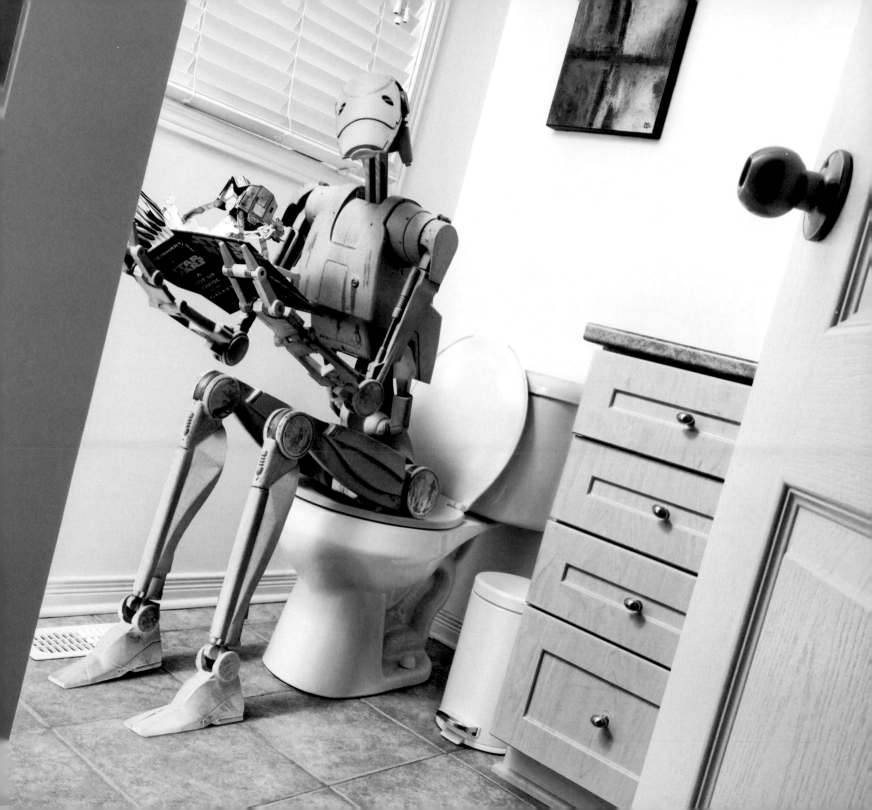

SUPERMAN KEEPS AN EYE ON A
BEACH IN MALIBU AS A LIFEGUARD.

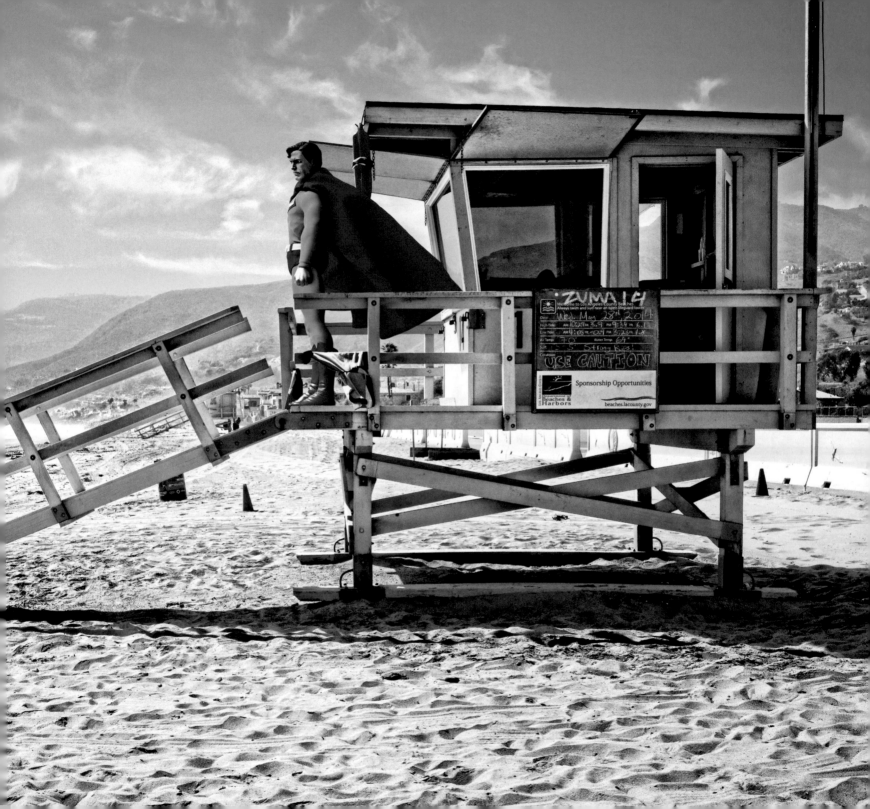

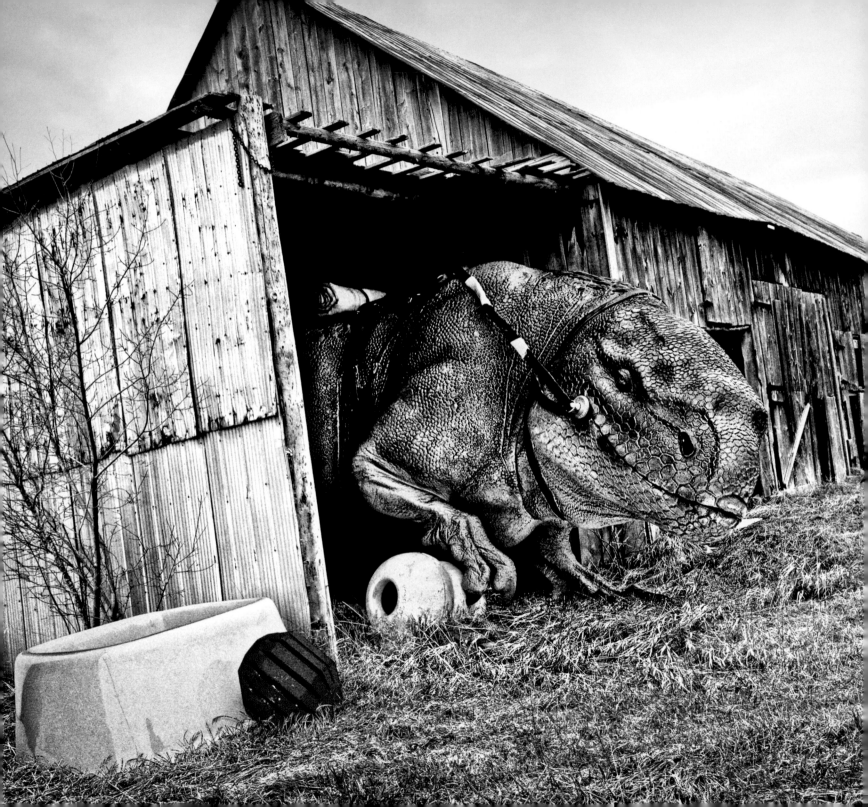

A PET DEWBACK PLAYS WITH TOYS
IN HIS STABLE-LIKE SHELTER.

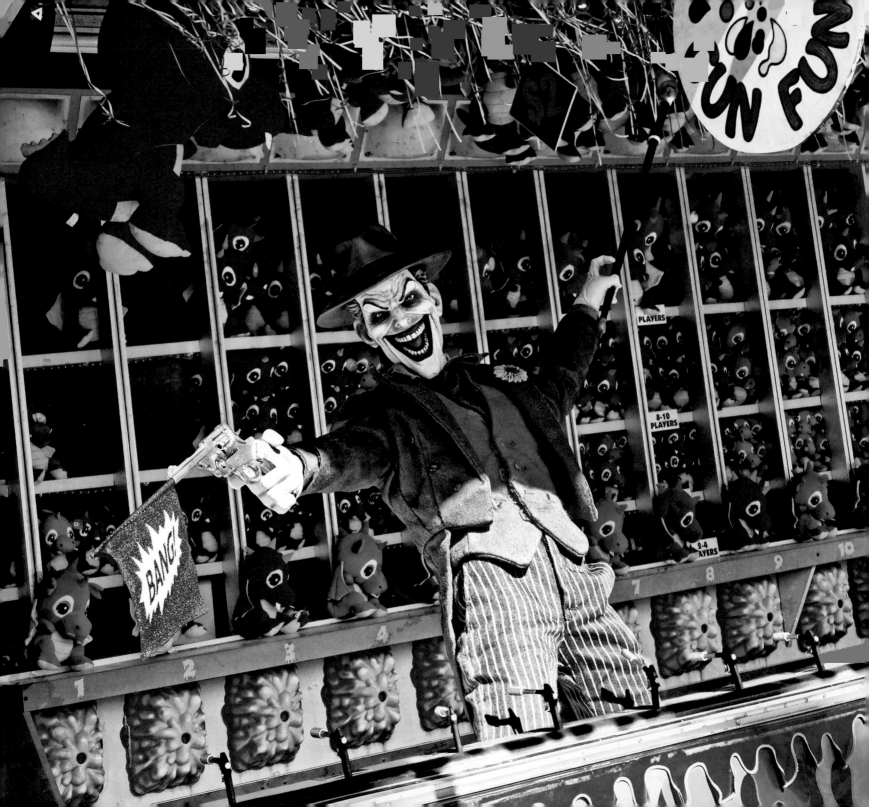

"The Joker is known for using abandoned theme parks for his hideouts, so I wanted a photo that had that kind of setting. I went to my local annual town fair looking for the perfect game for him. His face has the perfect expression—it's not really menacing; it's actually inviting. He wants you to participate. Whether or not the shooting game is rigged to explode is up to your imagination."

THE JOKER RUNS A CARNIVAL GAME AT A FAIR.

A STORMTROOPER PLAYS PAPER BASKETBALL IN HIS OFFICE.

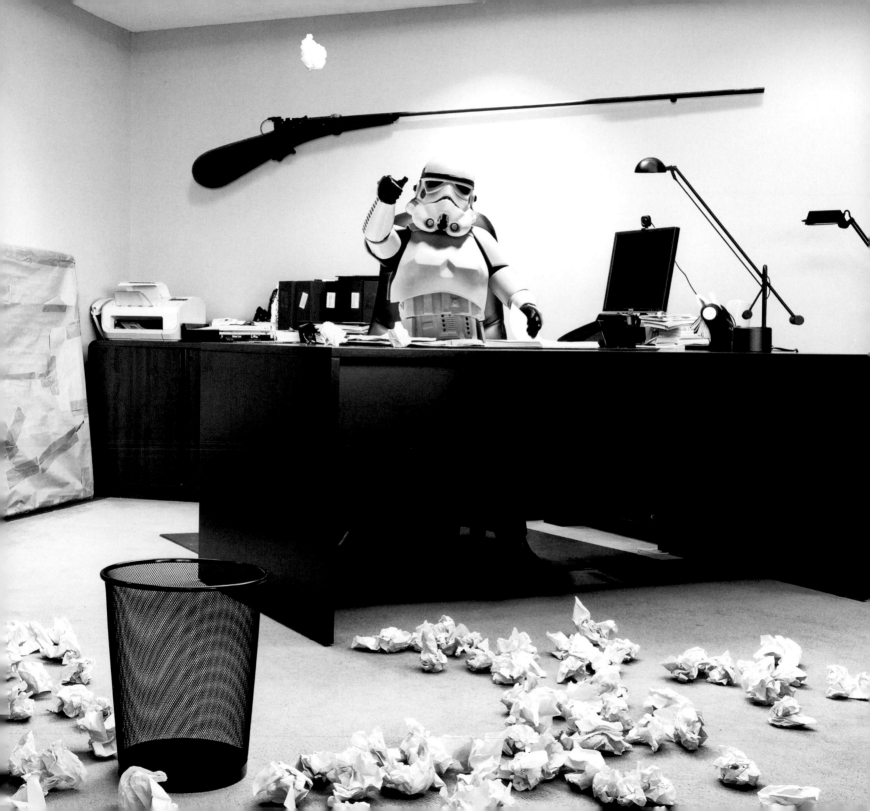

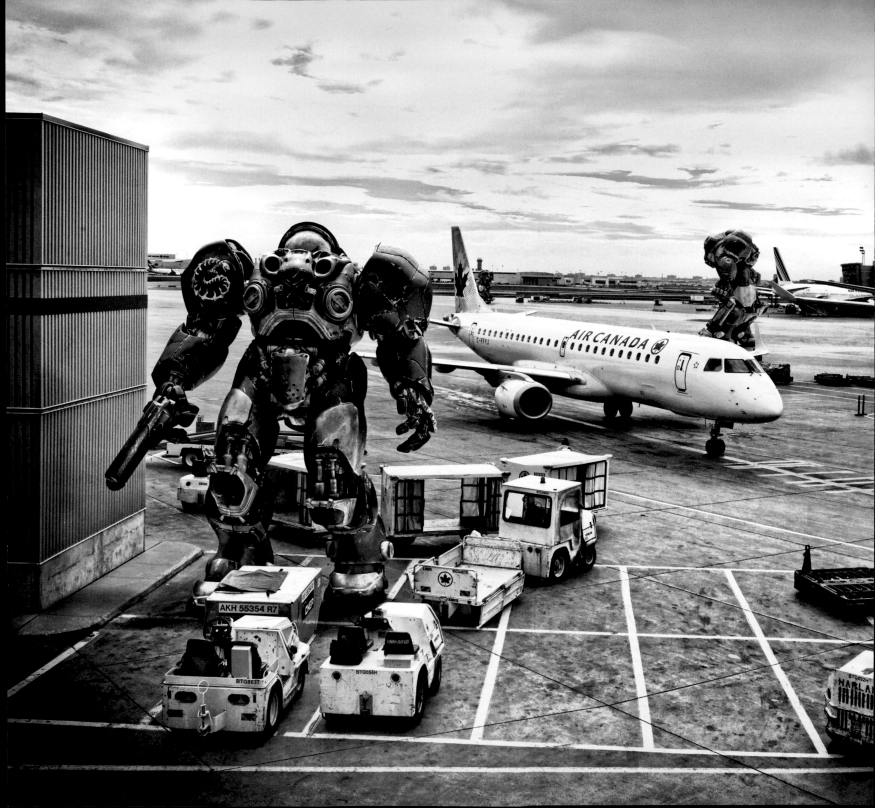

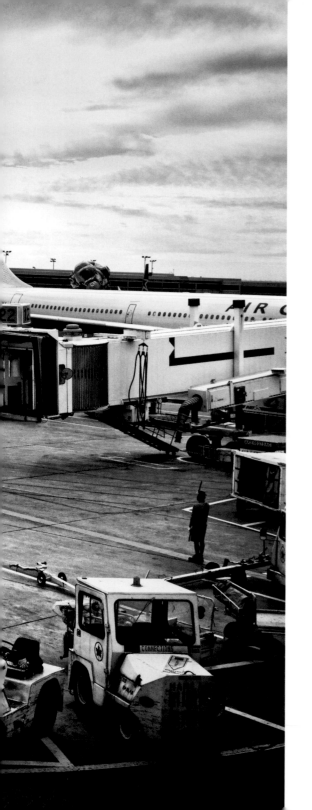

STARCRAFT'S JIM RAYNOR MANAGES AIRPORT SECURITY.

AN AWKWARD BOUNTY HUNTER ELEVATOR MOMENT.

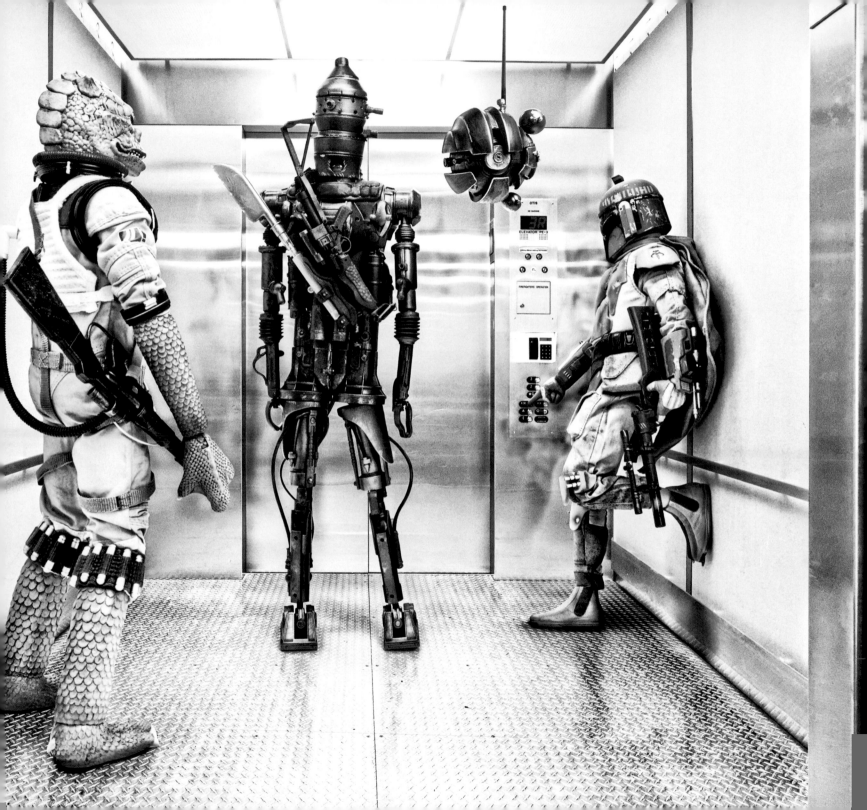

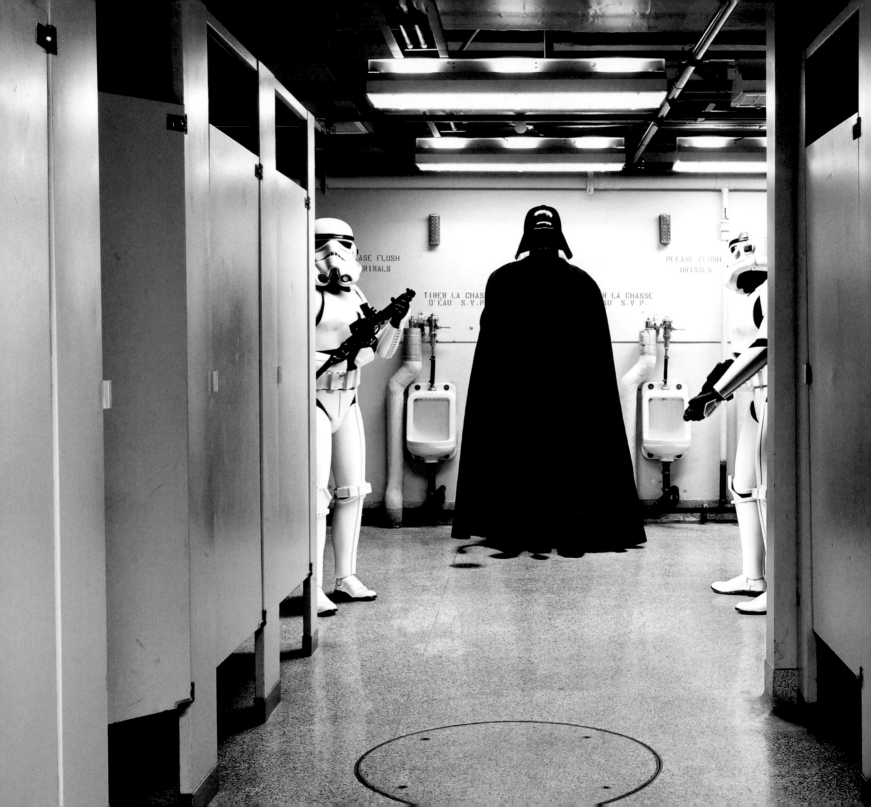

" It's always fun to think about what these dark, serious characters are like when they're not planning their next moves. It's all about the element of surprise. I don't want to show Darth Vader doing what he's known for. I want to capture him with his defenses down."

STORMTROOPERS GUARD DARTH VADER WHILE HE USES THE URINAL.

RAYNOR CASUALLY LIFTS A TANK WHILE FLIRTING WITH THE BARONESS (G.I. JOE).

DARTH MALGUS (STAR WARS) RECEIVES ORDERS FROM TIM
THE ENCHANTER (*MONTY PYTHON AND THE HOLY GRAIL*).

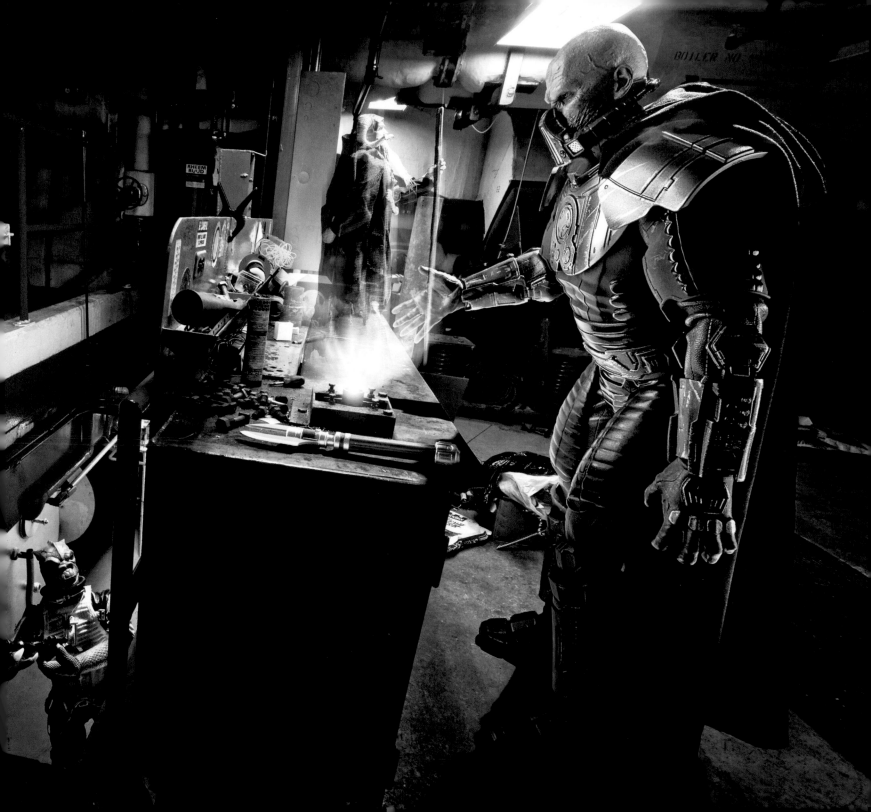

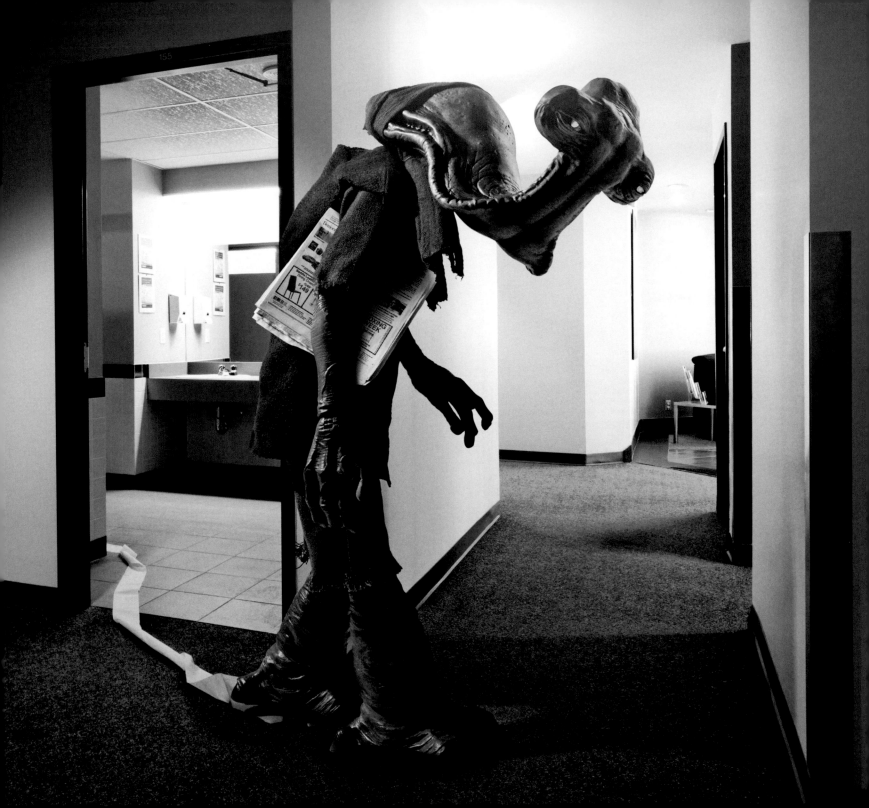

HAMMERHEAD MOMAW NADON (STAR WARS)
LEAVES A TOILET PAPER TRAIL.

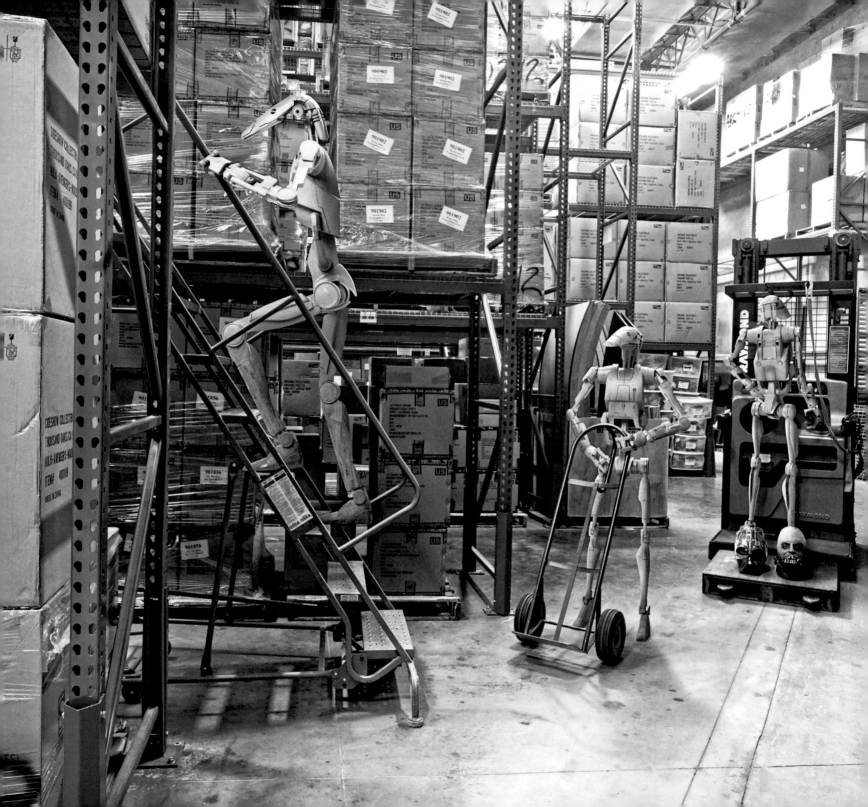

BATTLE DROIDS FIND WORK AT THE SIDESHOW
COLLECTIBLES WAREHOUSE.

THE JOKER BUILDS A JOKER-THEMED PLAY SET IN HIS FREE TIME.

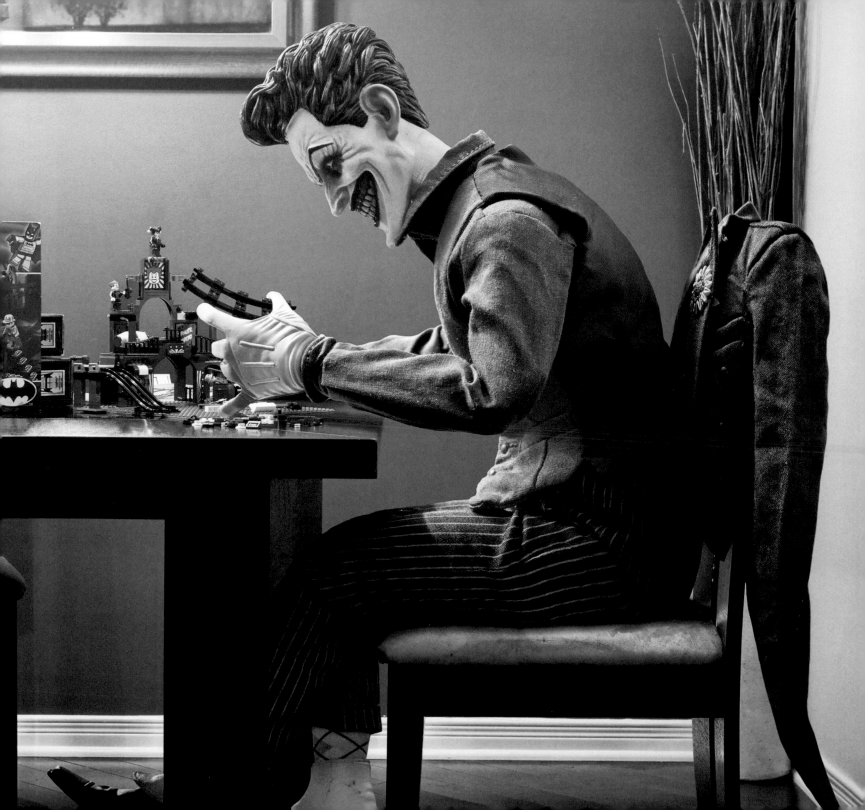

A GAMORREAN FROM STAR WARS
GUARDS A BUNKER DOOR.

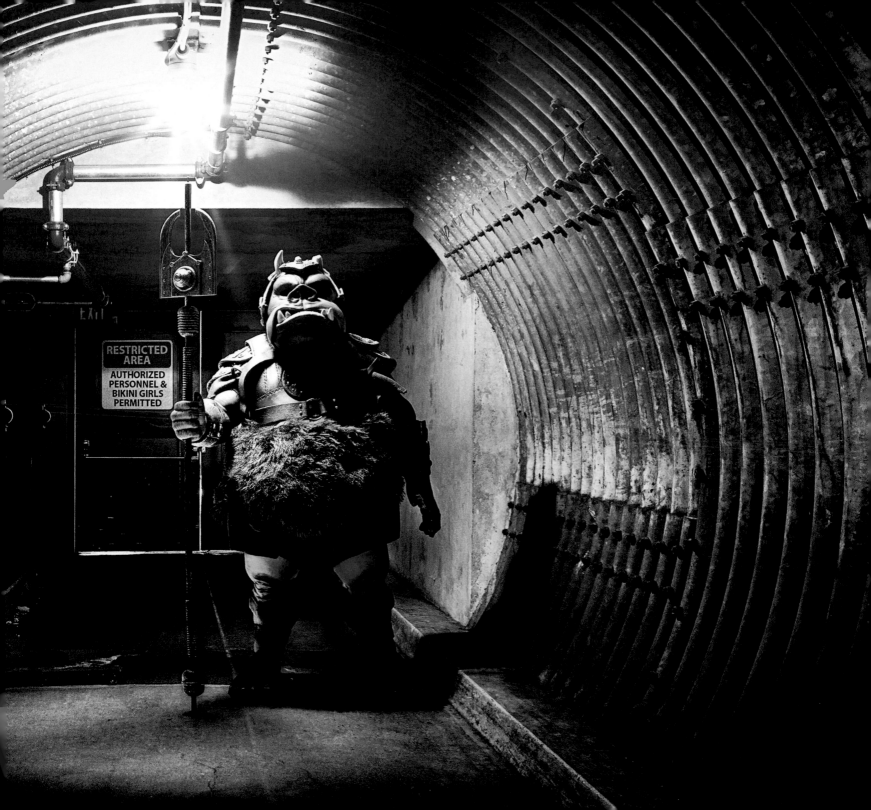

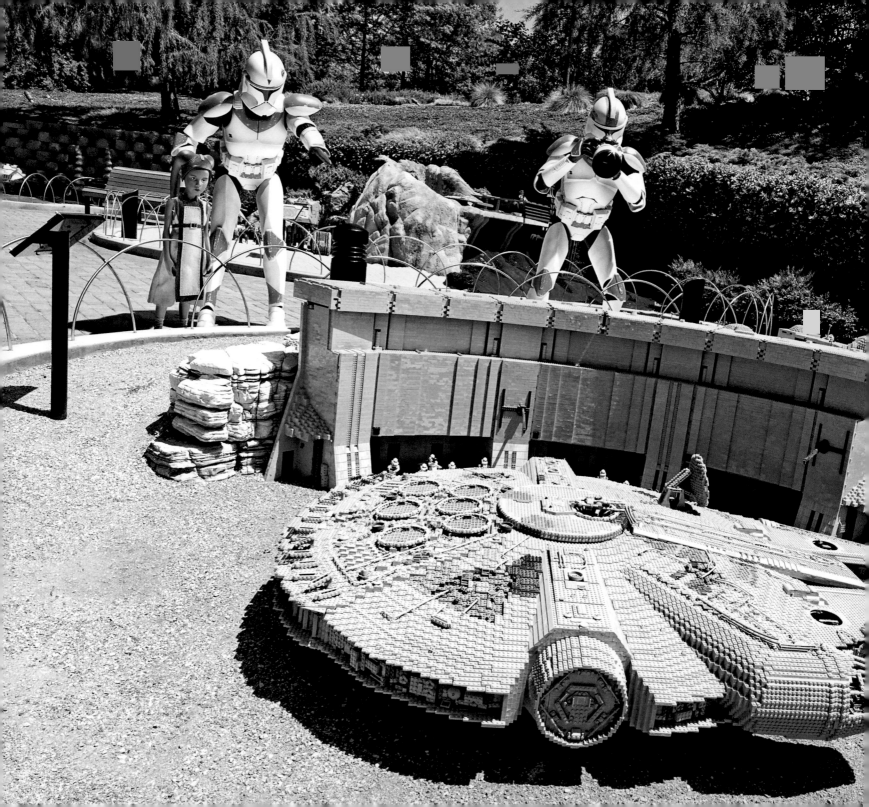

CLONE TROOPERS BOIL AND WAXER ENJOY
SOME LEISURE TIME AT LEGOLAND.

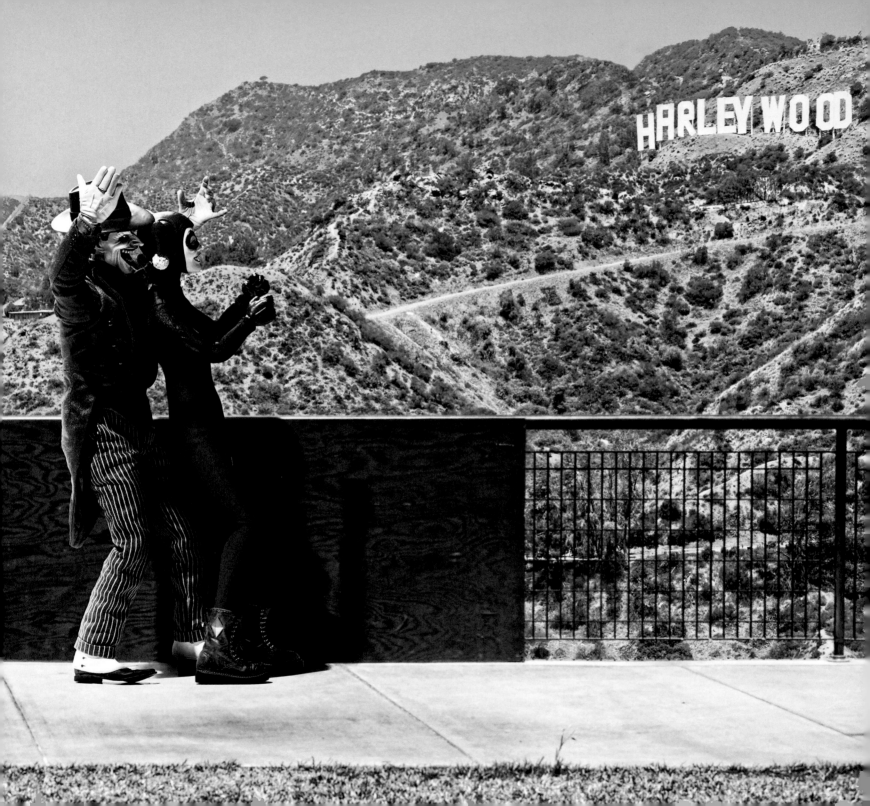

THE JOKER SURPRISES HARLEY QUINN WITH
A TWEAK TO THE HOLLYWOOD SIGN.

STAR WARS' IG-88 ENJOYS YOGA ON THE BEACH.

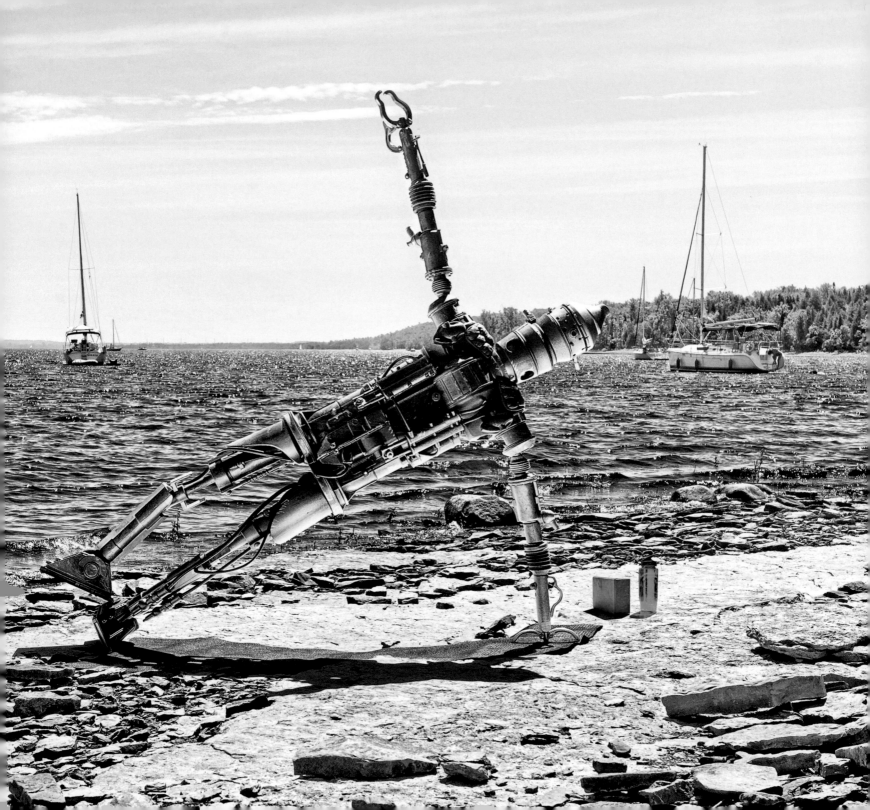

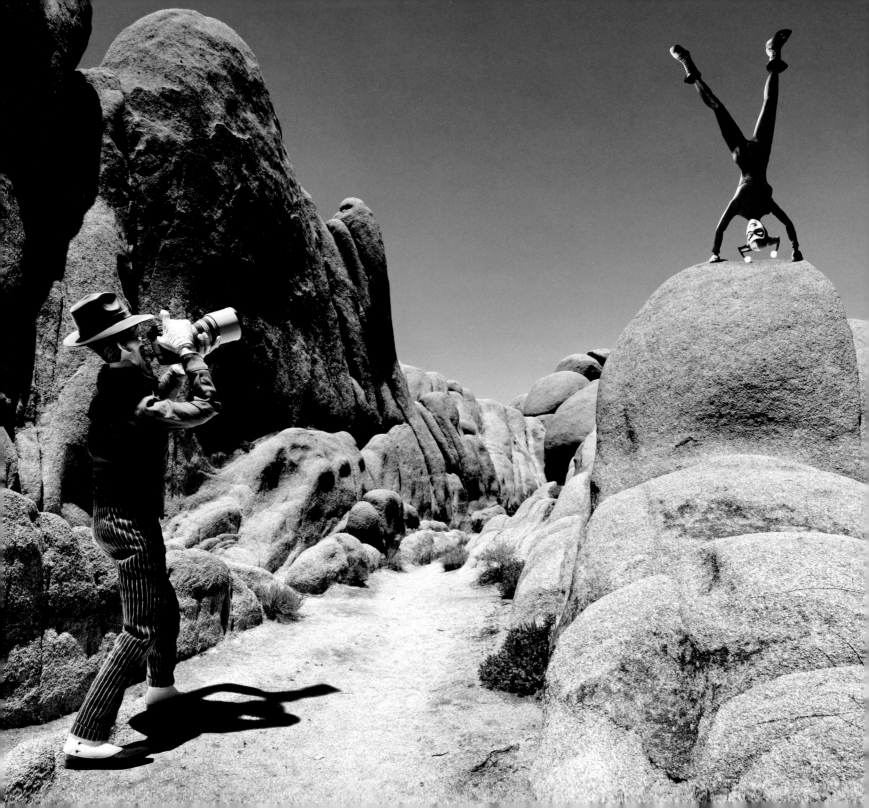

THE JOKER SNAPS HARLEY QUINN IN A YOGA POSE.

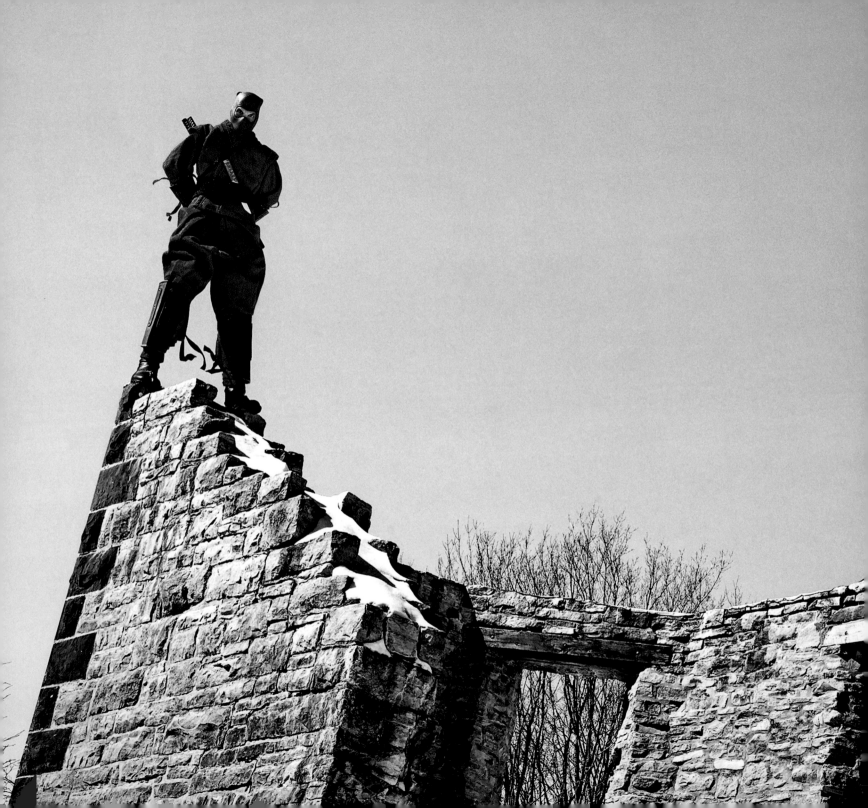

G.I. JOE'S RED NINJA HAS A QUIET MOMENT ON A RUIN.

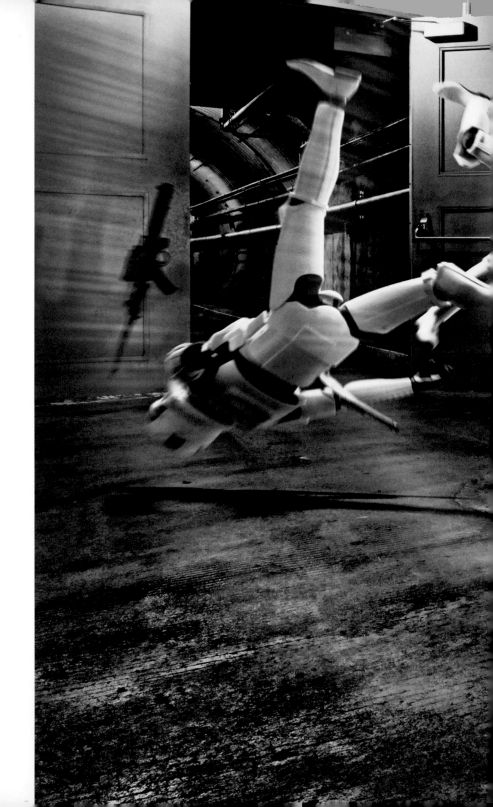

YODA TEXTS WHILE BATTLING STORMTROOPERS.

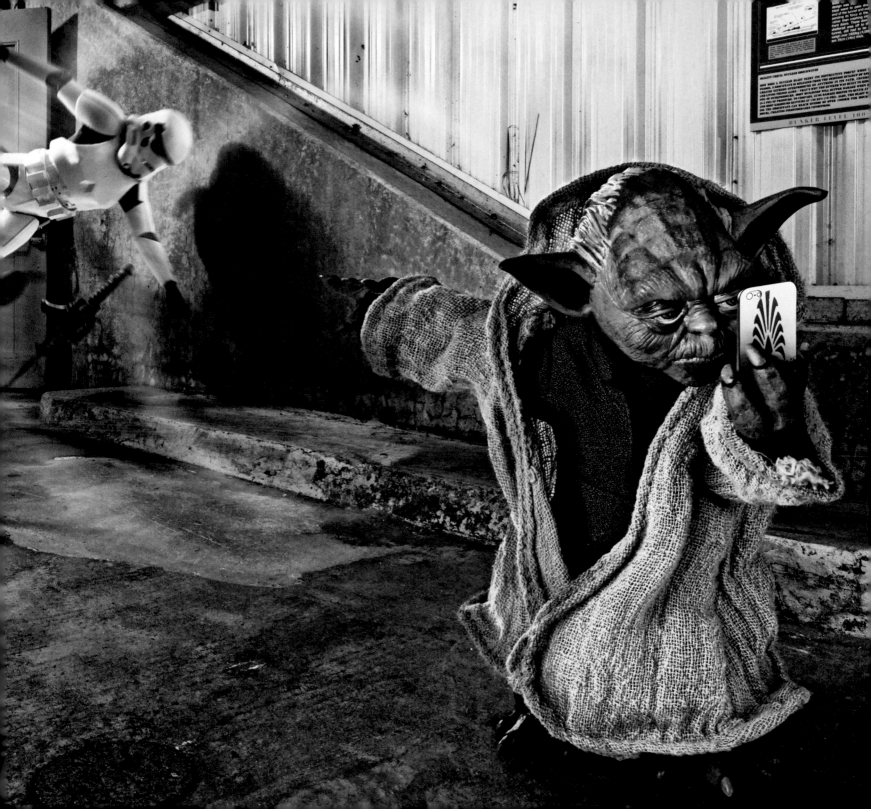

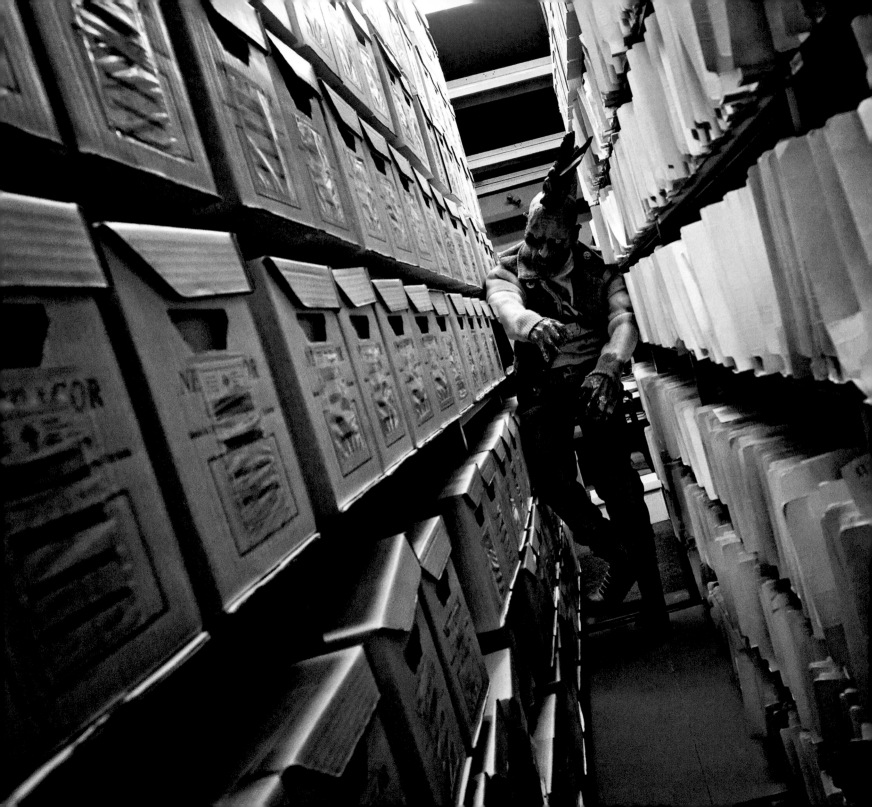

PUNK ZOMBIE HAUNTS AN ARCHIVE ROOM.

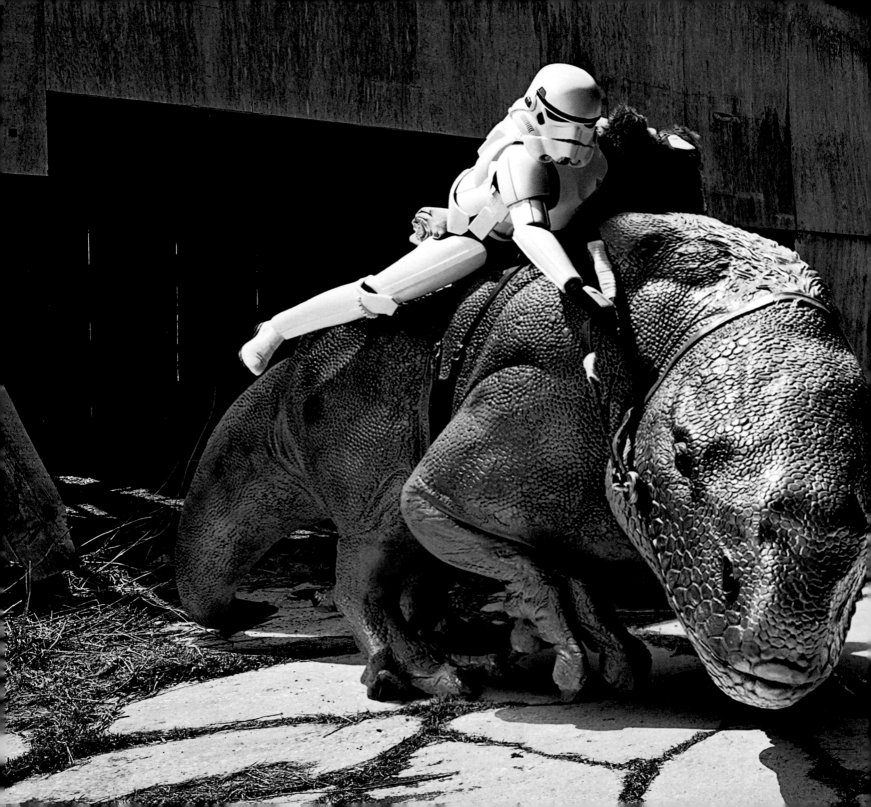

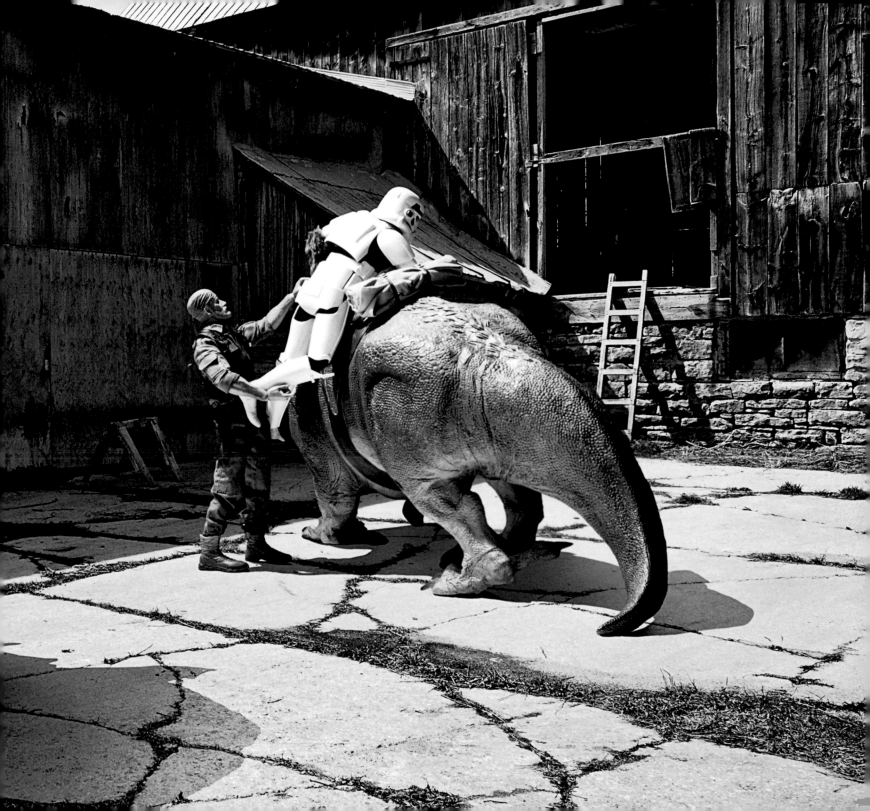

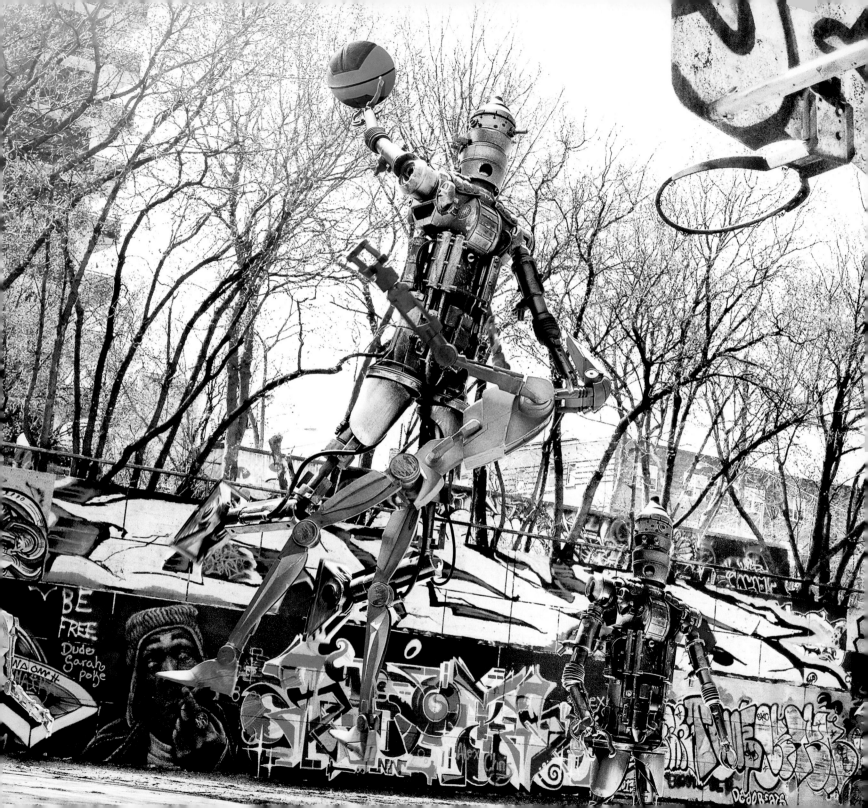

PREVIOUS PAGES: DEWBACK RIDING LESSONS.

LEFT: IG-88S AND BATTLE DROIDS SHOOT SOME HOOPS.

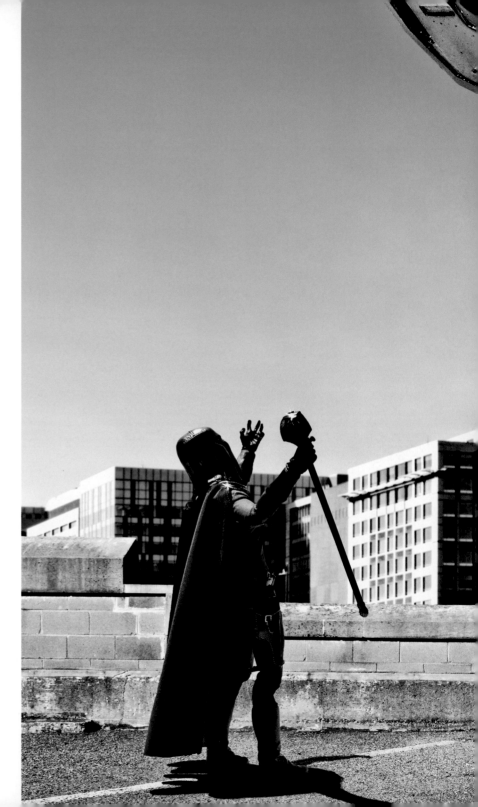

"One of the things I most enjoy doing is having characters from different universes face each other. That's what I did here with Galactus and Cobra Commander. Galactus is known for eating planets, so I imagined what it would be like for Cobra Commander to try and talk him out of this. Maybe he could convince Galactus to eat the much larger Saturn instead of our tiny Earth?"

MARVEL VILLAIN GALACTUS FACES OFF
WITH COBRA COMMANDER.

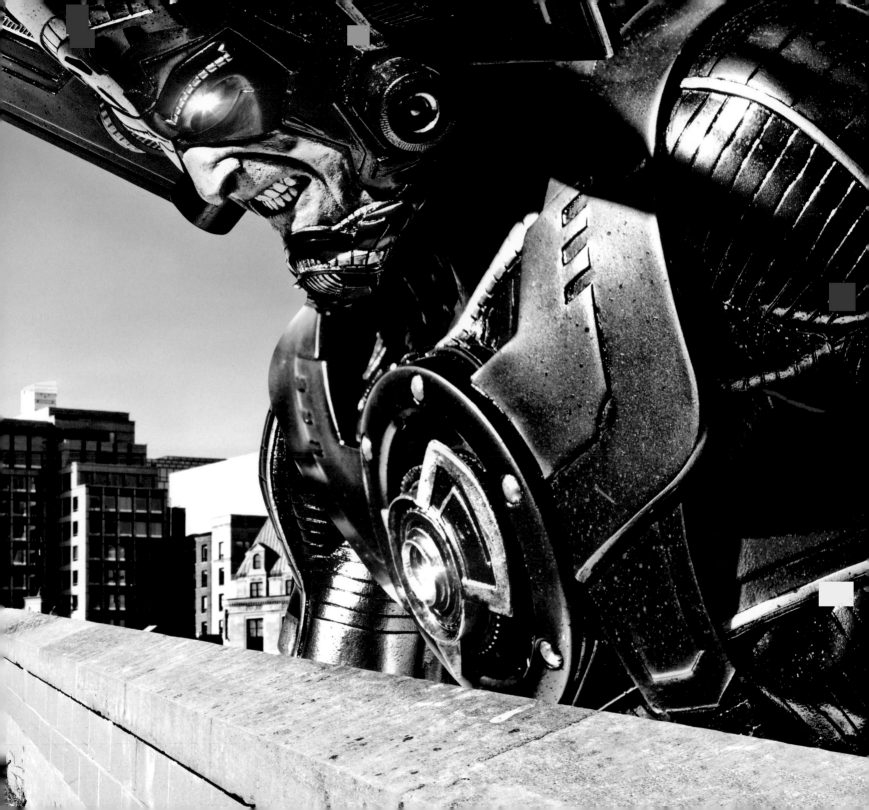

"This was my very first photo using a sixth-scale figure, so it's very special to me. It started what have become two wonderful hobbies—collecting figures and taking photos of them."

A STORMTROOPER KILLS SOME TIME ON A TRAIN TRACK.

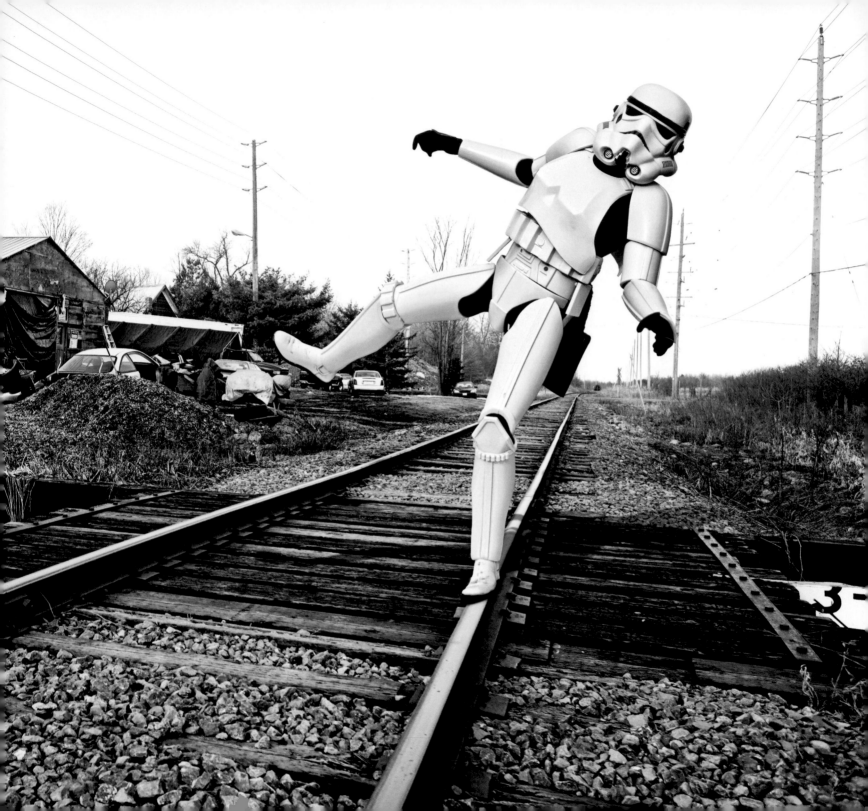

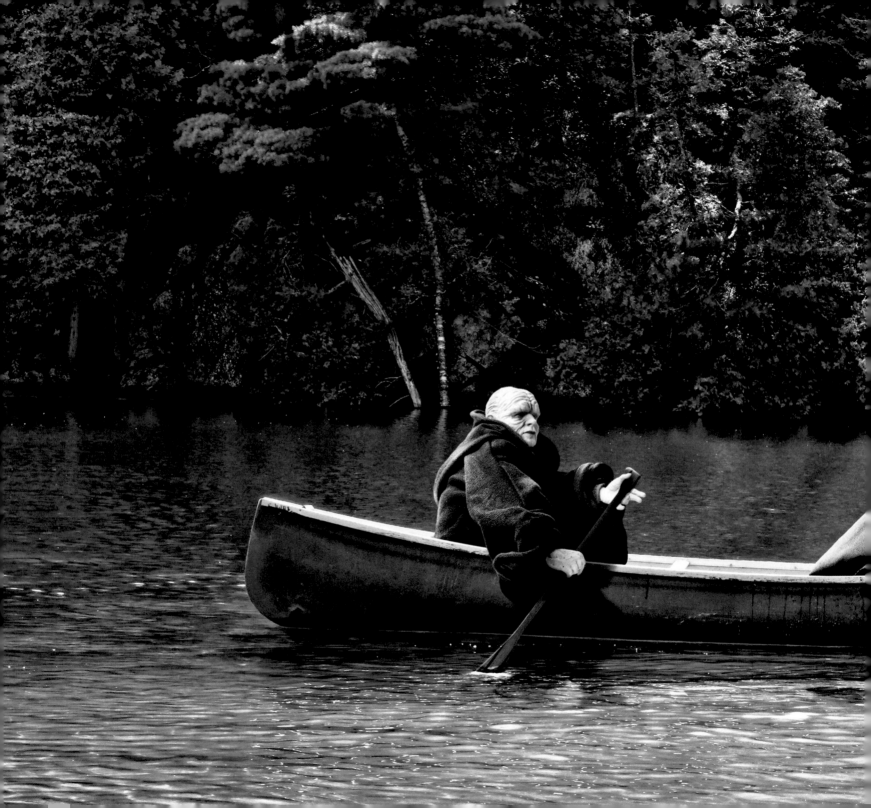

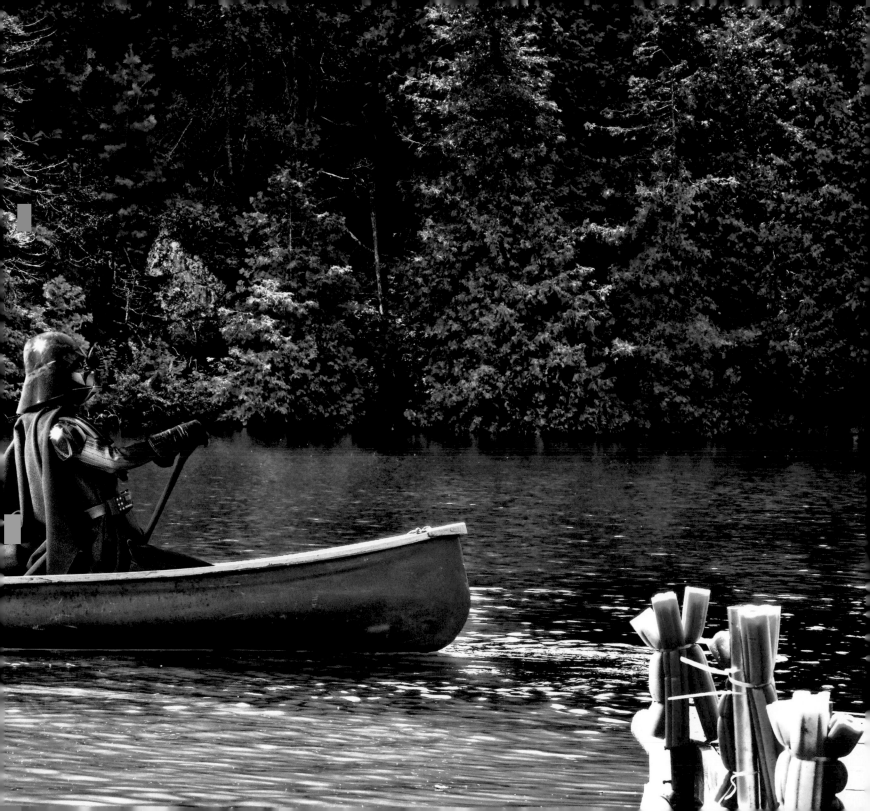

"Many of my photos focus on famous heroes and villains doing things that we don't usually associate with their characters. After all, they need hobbies, too. I like to imagine them in normal houses and places, doing regular everyday things. I was very excited when I heard that a Jango figure was being made. It gave me the opportunity to pair him with Boba Fett and create some nice father-and-son photos featuring two very dangerous individuals."

PREVIOUS PAGES: DARTH VADER AND EMPEROR PALPATINE
ENJOY A PEACEFUL CANOE RIDE ON THE LAKE.
RIGHT: JANGO AND BOBA FETT GO FISHING.

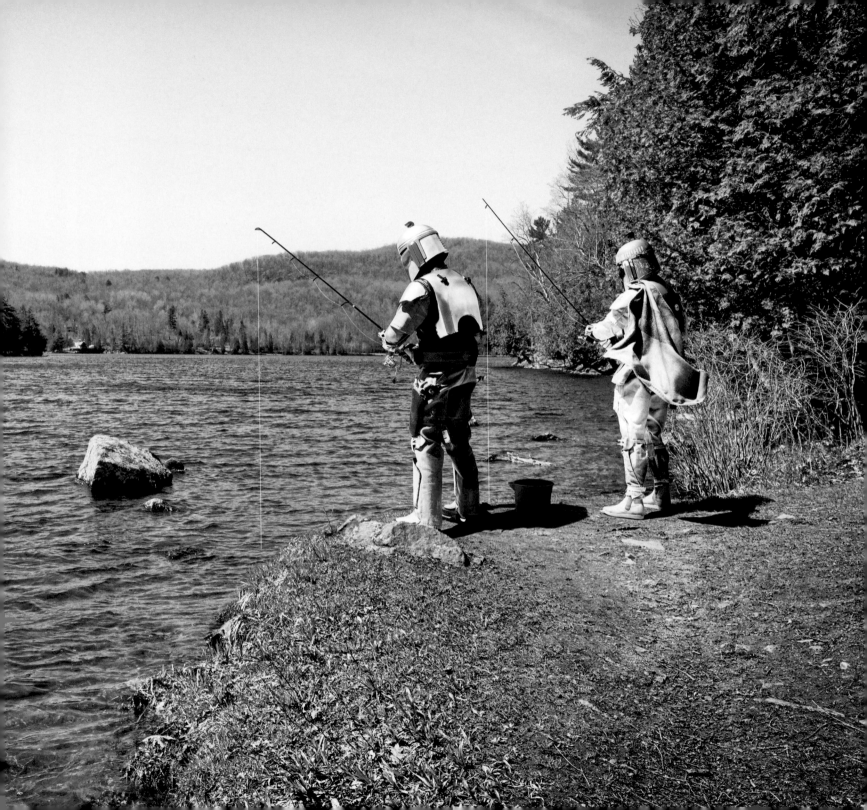

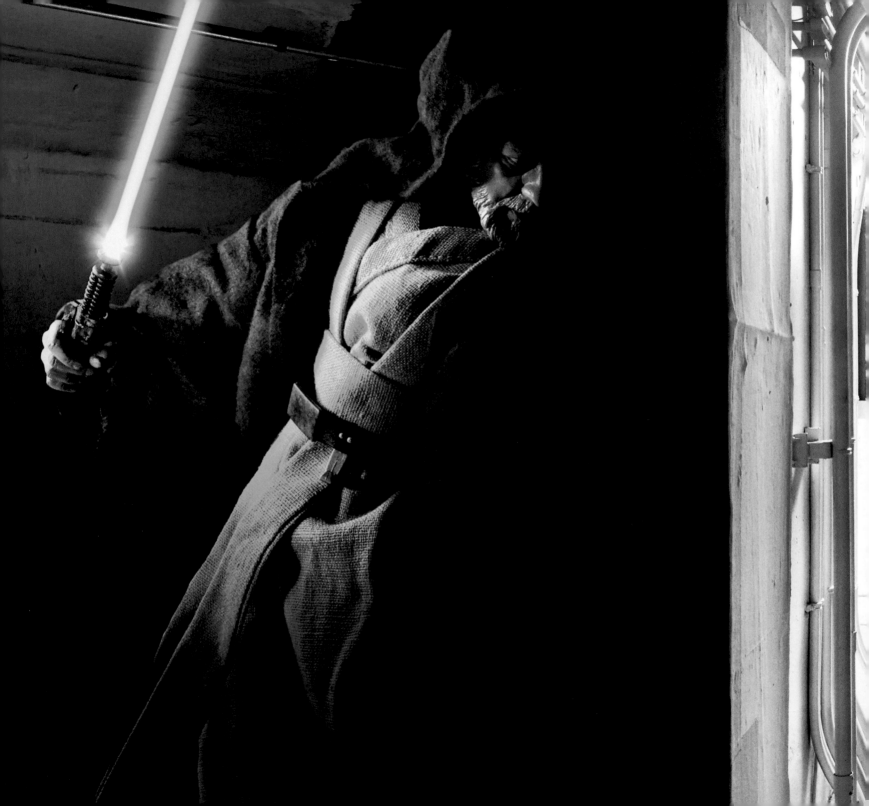

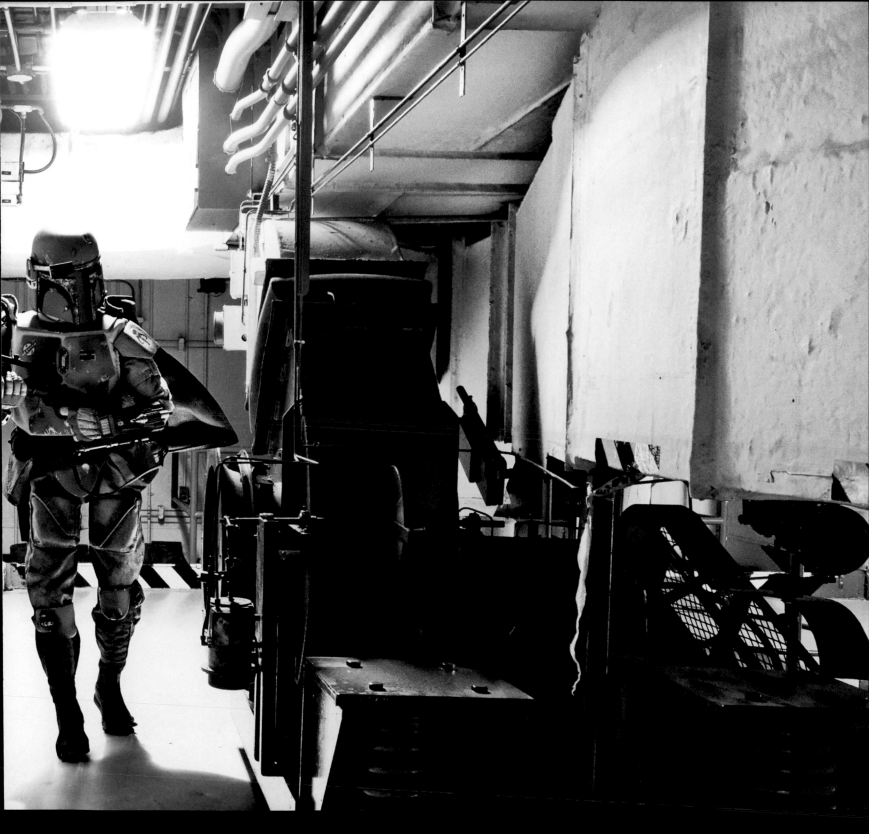

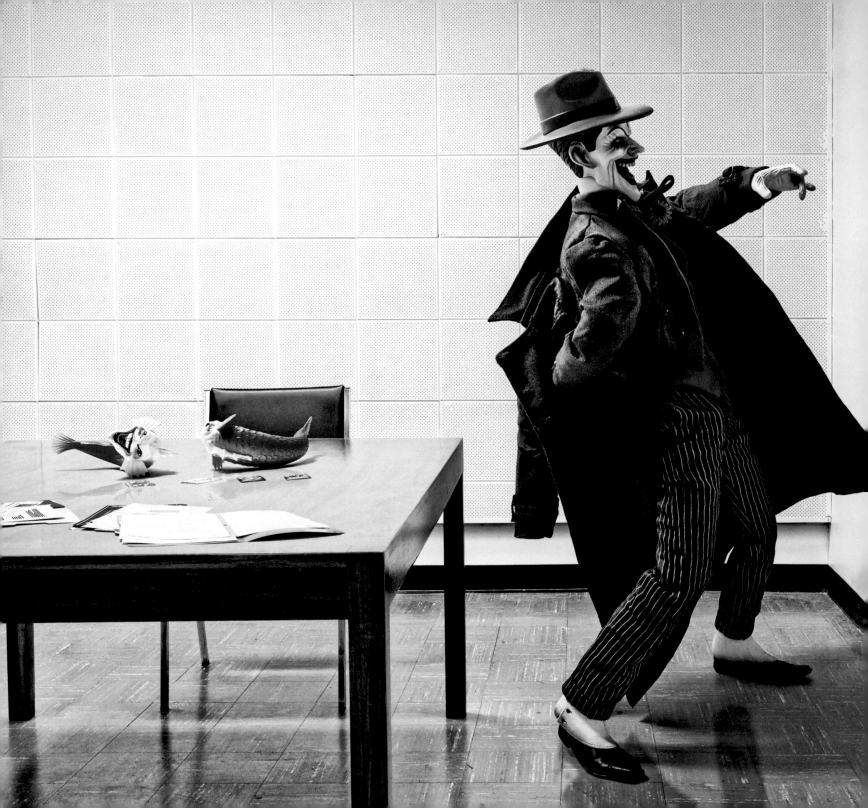

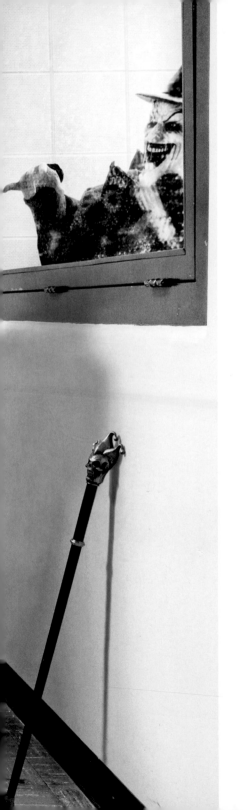

“The Joker figure came with great accessories, including two Joker-faced fish, which I used in this police interrogation. I imagined Joker laughing at the cops and Batman, who are all watching him from the other side of the mirror. He knows that they can't charge him with anything.”

PREVIOUS PAGES: OBI-WAN KENOBI WAITS FOR THE PERFECT MOMENT TO STRIKE.
LEFT: THE JOKER MOCKS BATMAN AS HE PREPARES TO LEAVE THE INTERROGATION ROOM.

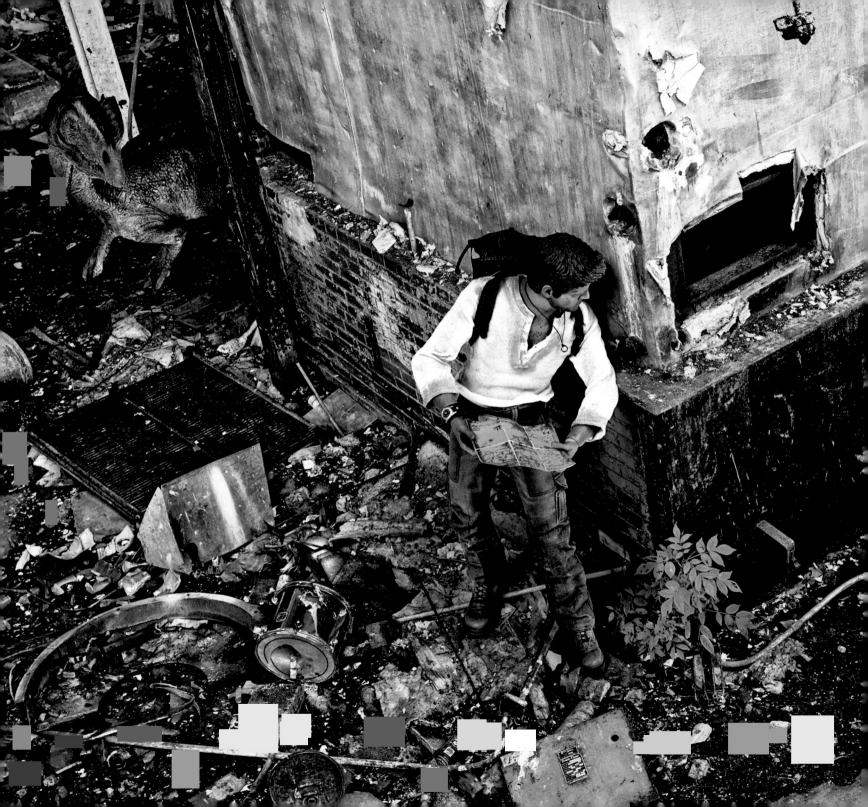

“Nathan Drake is the character in my collection to whom I relate the most. That's why I use him for impossible scenes that I would love to be part of but that would never happen in real life.”

A SLY DINOSAUR FROM SIDESHOW COLLECTIBLES' DINOSAURIA
LINE SNEAKS UP ON *UNCHARTED* HERO NATHAN DRAKE.

87

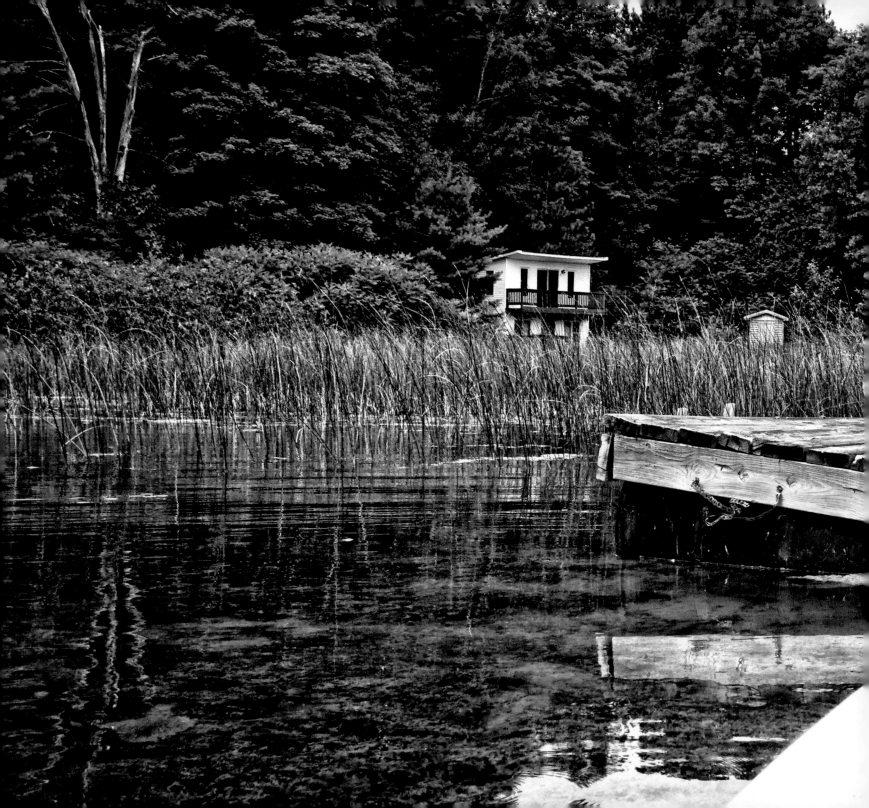

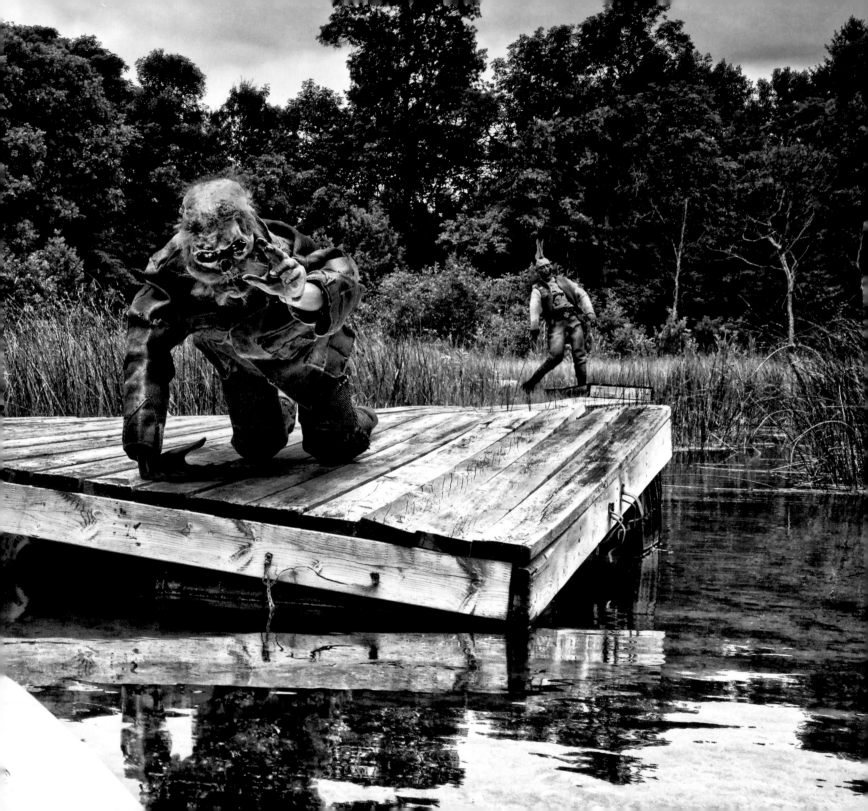

"I came across an abandoned theme park while on vacation one summer and was able to get permission from the owner to shoot there. I was all alone for a few hours as I toured the broken-down buildings, so I immediately went into zombie and horror movie mode and started looking for a cool scene for my Jason figure. Mr. White from *Reservoir Dogs* is the figure I use whenever I need a detective or special agent, but I think he should have waited for backup that day."

PREVIOUS PAGES: ZOMBIES TAKE OVER A SUMMER RENTAL CABIN.
RIGHT: JASON (*FRIDAY THE 13TH*) DRAGS MR. WHITE (*RESERVOIR DOGS*) INTO AN ABANDONED BUILDING.

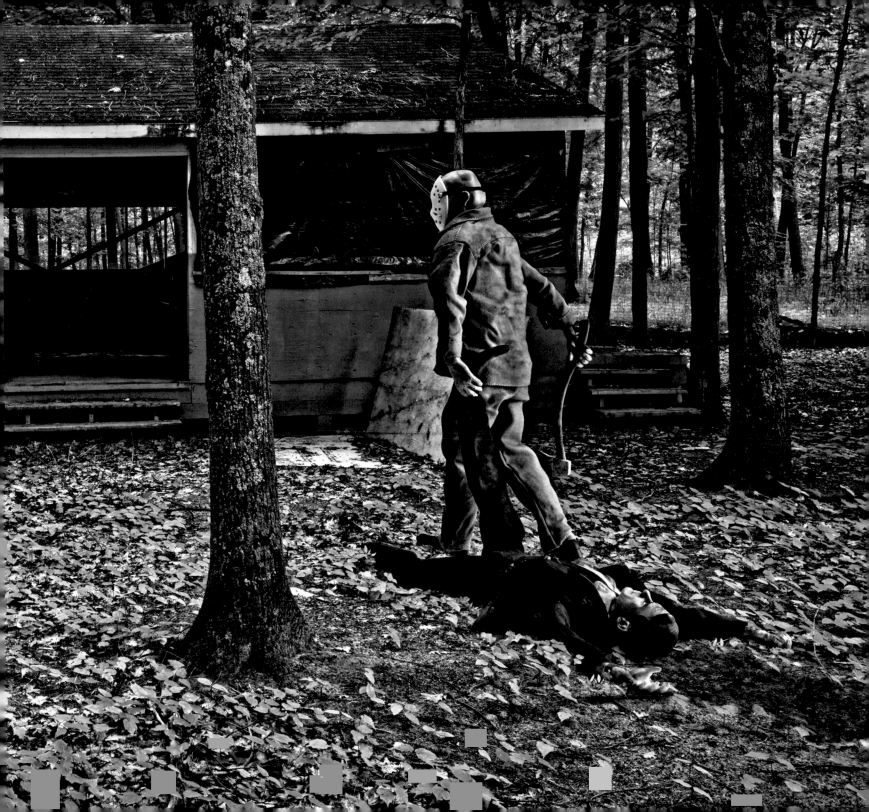

GENERAL GRIEVOUS FROM STAR WARS GIVES
ORDERS TO MAJOR BLUDD FROM G.I. JOE.

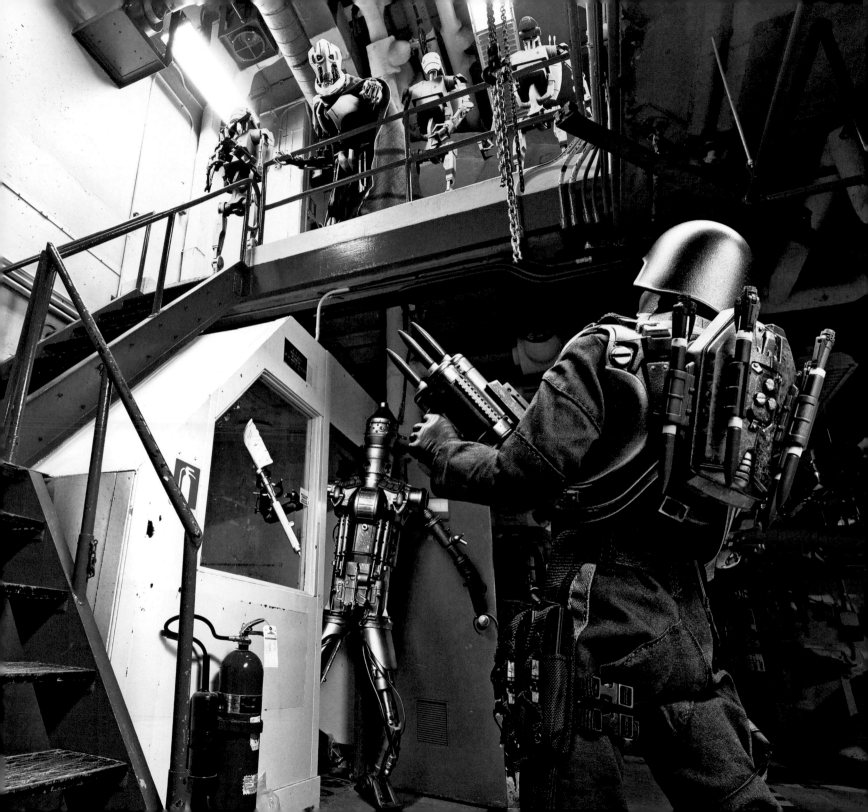

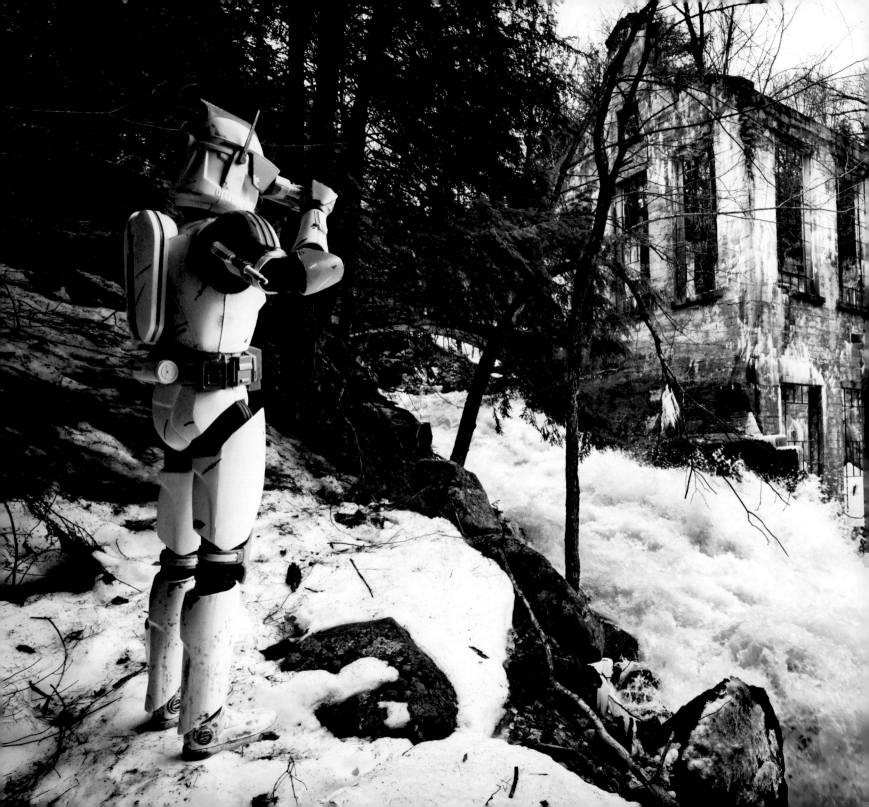

"I am always on the lookout for unique backdrops for my photos. One of my local favorites is this abandoned phosphate mill near Meech Lake, Quebec, where I've shot lots of photos."

CLONE COMMANDER CODY KEEPS WATCH ON THE RUIN BY THE FALLS.

" My favorite location to take photos with my collectibles is the Diefenbunker, a real Cold War–era bunker near where I live. This photo is set in the vault on the bottom floor, and it was kind of obvious that I had to use Catwoman, because she loves to steal. I added the Batman shadow to evoke a scene from a comic book. I think Catwoman is such a phenomenal, iconic character. She can do good things, bad things, or just regular everyday things—there's a lot of potential there for interesting photographs."

CATWOMAN EXITS A VAULT DURING A HEIST.

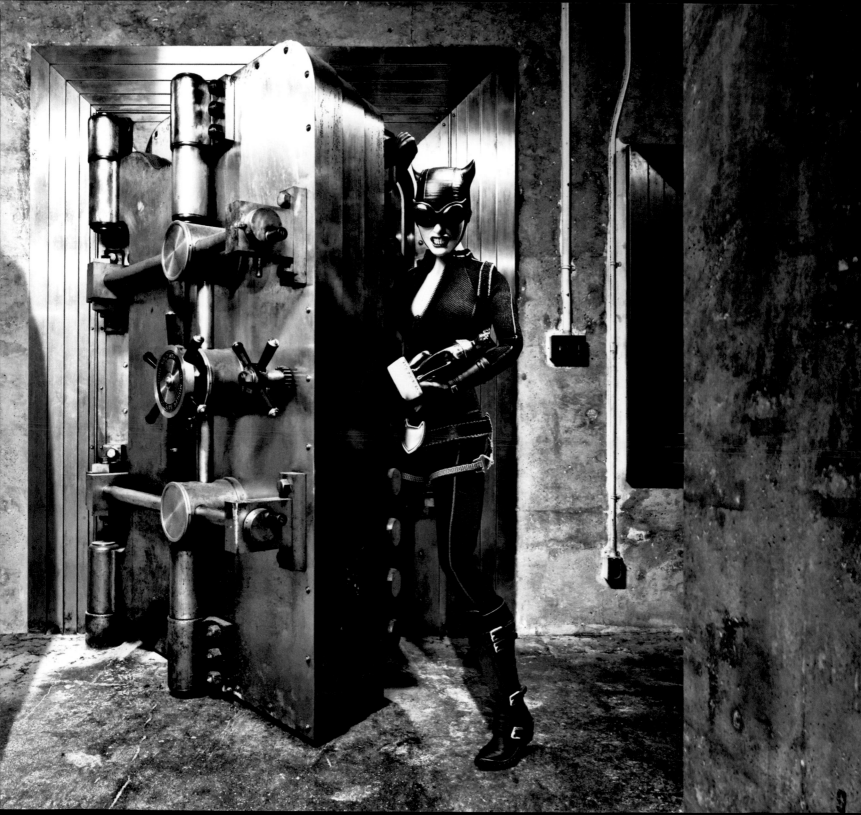

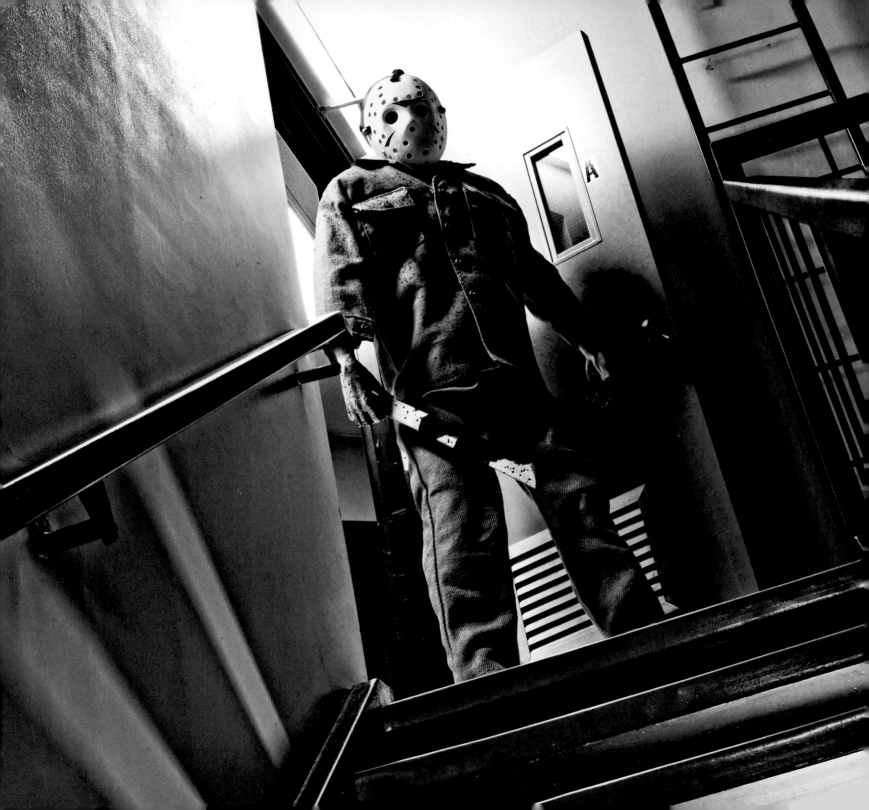

A MENACING JASON WAITS AT
THE TOP OF THE STAIRS.

THE JOKER AND HARLEY QUINN INTERROGATE
ROCK 'N' ROLL FROM G.I. JOE.

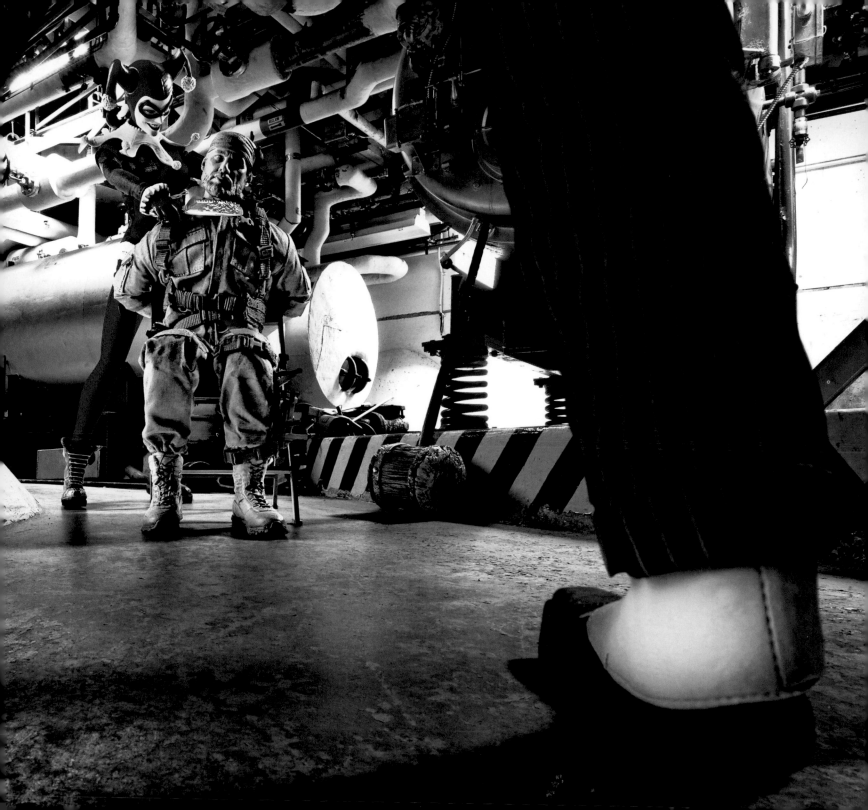

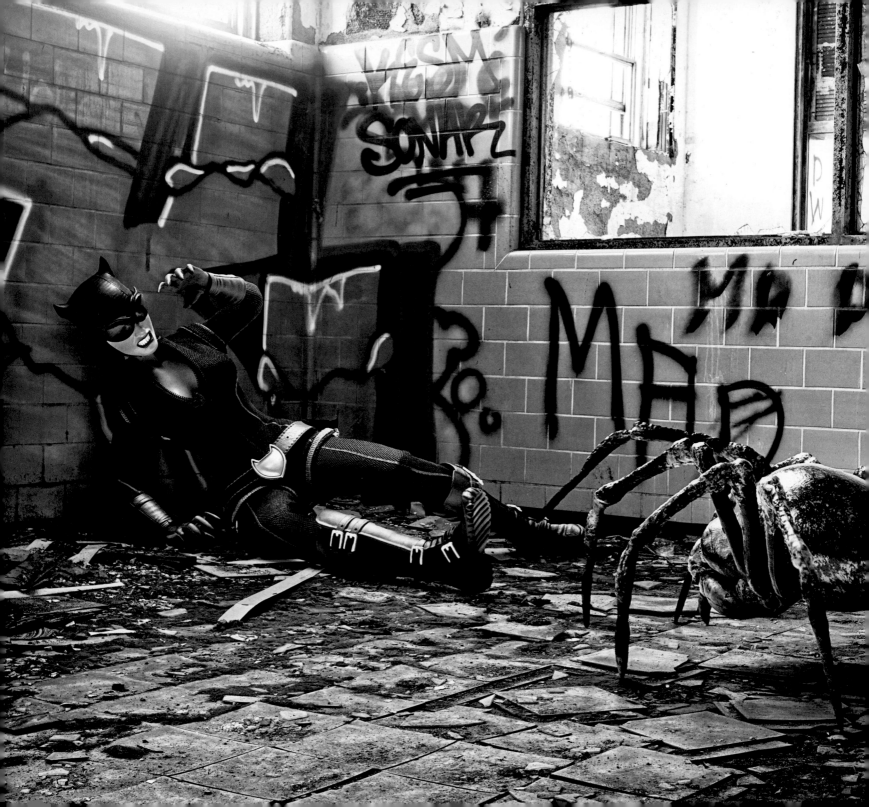

"Catwoman would certainly not be afraid of a regular-sized spider, so I had to give her a giant one—an insect that every woman, man, dog, or bear would probably be scared of."

CATWOMAN FACES DOWN A GIANT SPIDER.

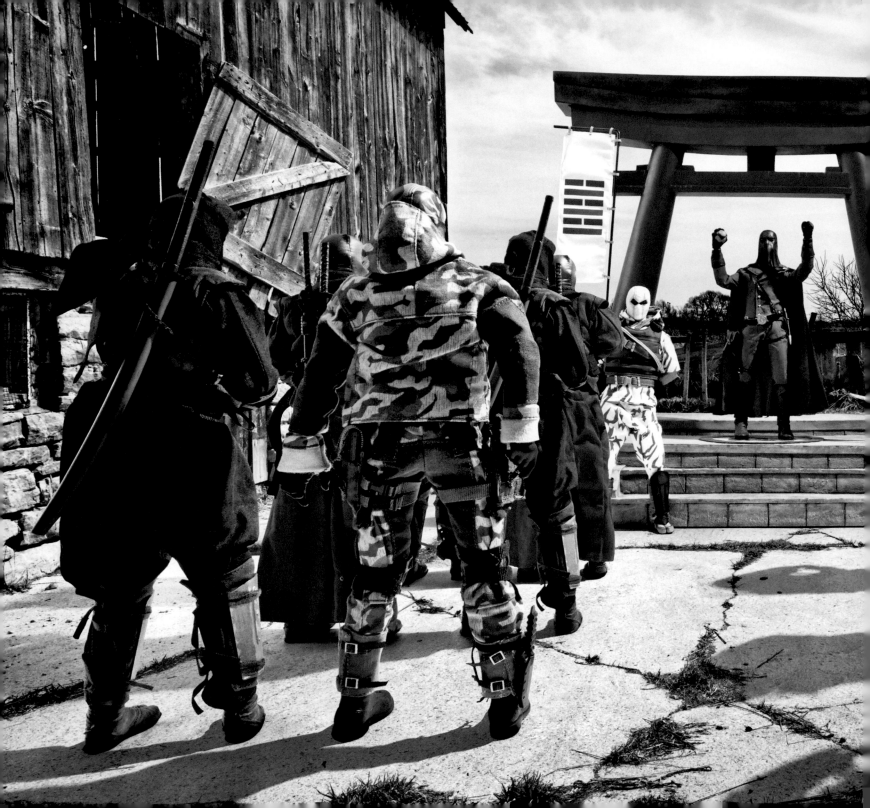

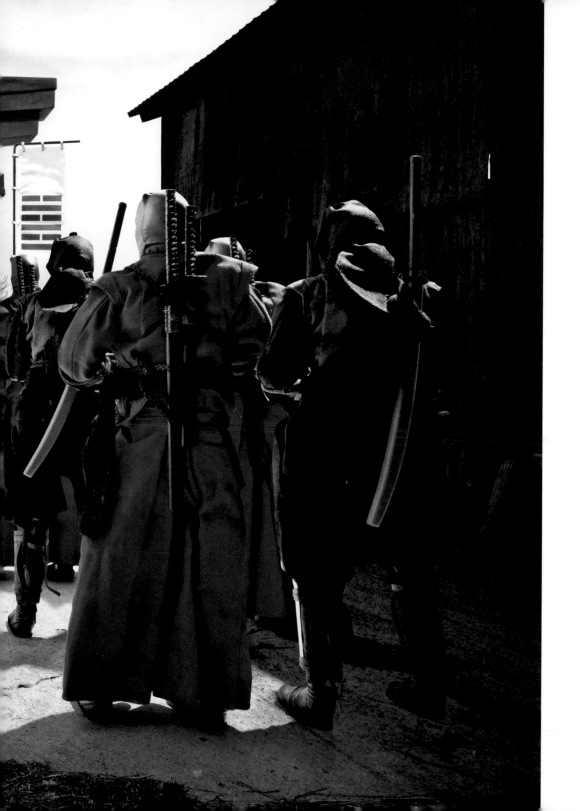

COBRA COMMANDER ADDRESSES A NINJA ARMY.

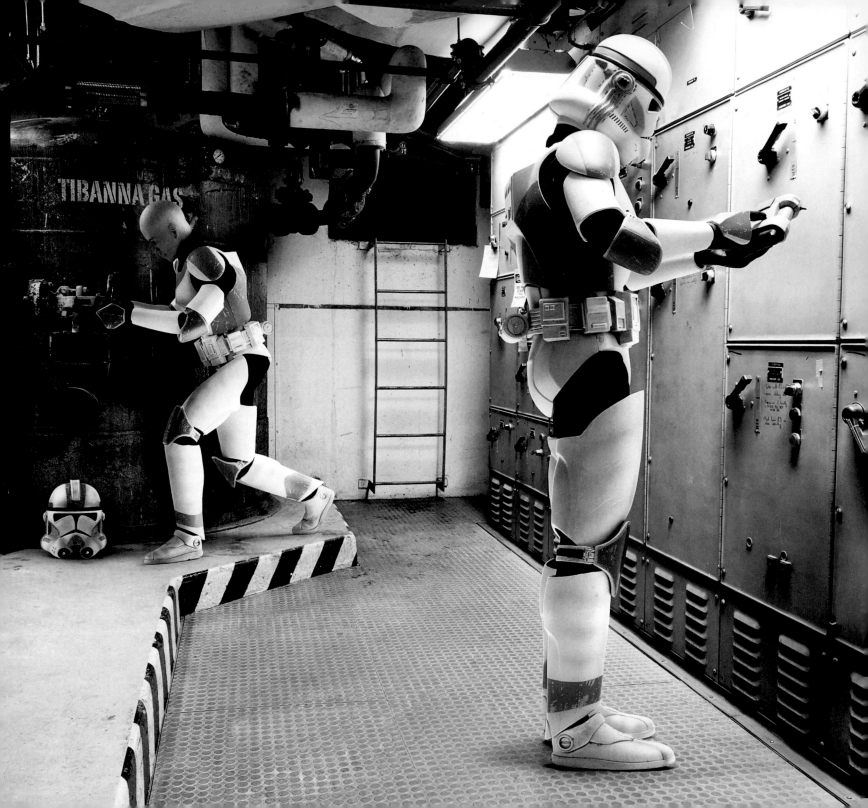

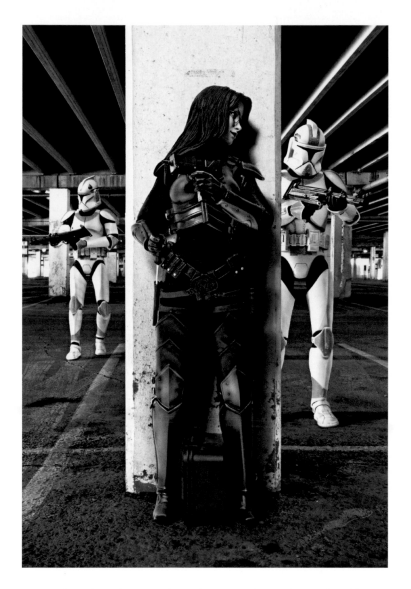

"When I have characters doing things that they are known for—like Baroness from G.I. Joe stealing secrets—I enjoy mixing universes to keep things interesting. She's stolen lots of things in the past, but never from a Star Wars character, and being able to show those kinds of stories is really fun for me."

OPPOSITE: A CLONE TROOPER WORKS WITH TIBANNA GAS.
RIGHT: THE BARONESS HIDES BEHIND A PILLAR.

JASON FIGHTS A TUSKEN RAIDER.

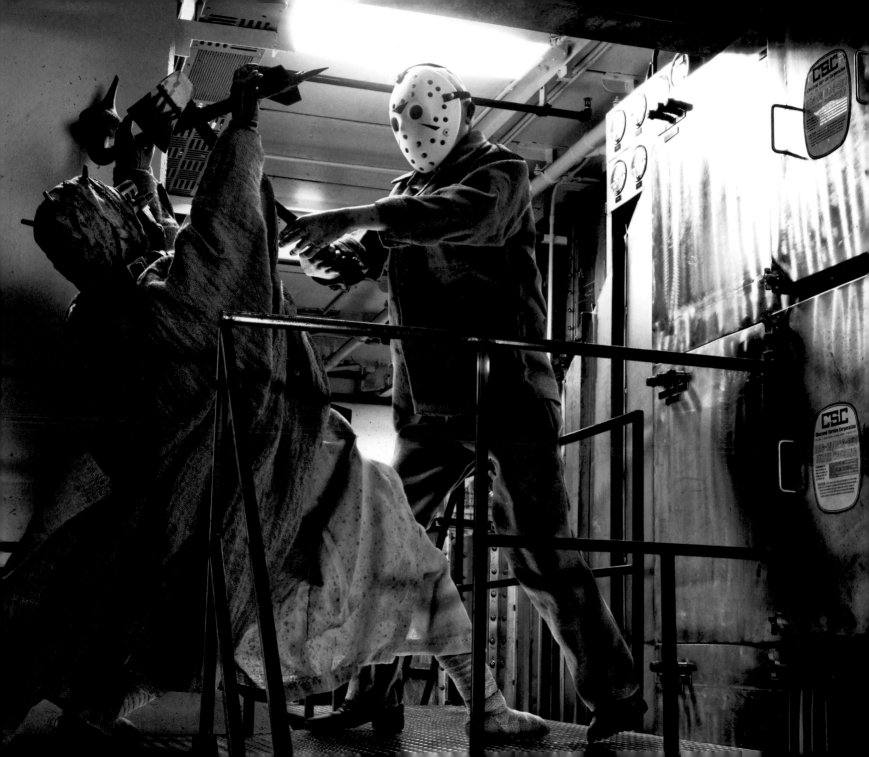

A BATTLE DROID REACHES FOR HIS GUN IN
A FIGHT WITH G.I. JOE'S BEACHHEAD.

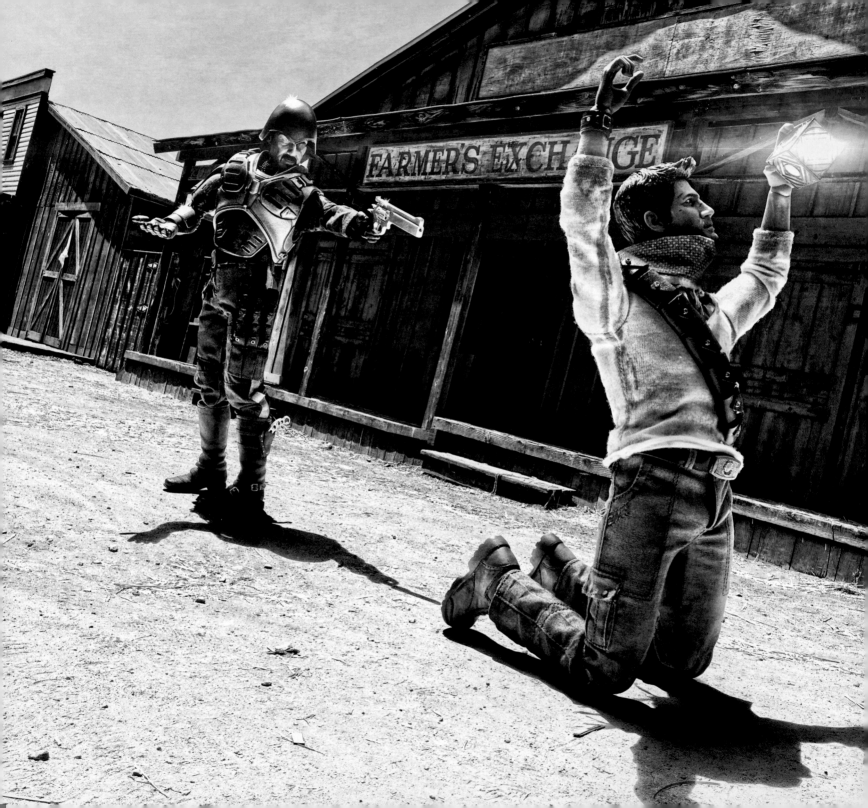

NATHAN DRAKE IS CAPTURED BY MAJOR BLUDD.

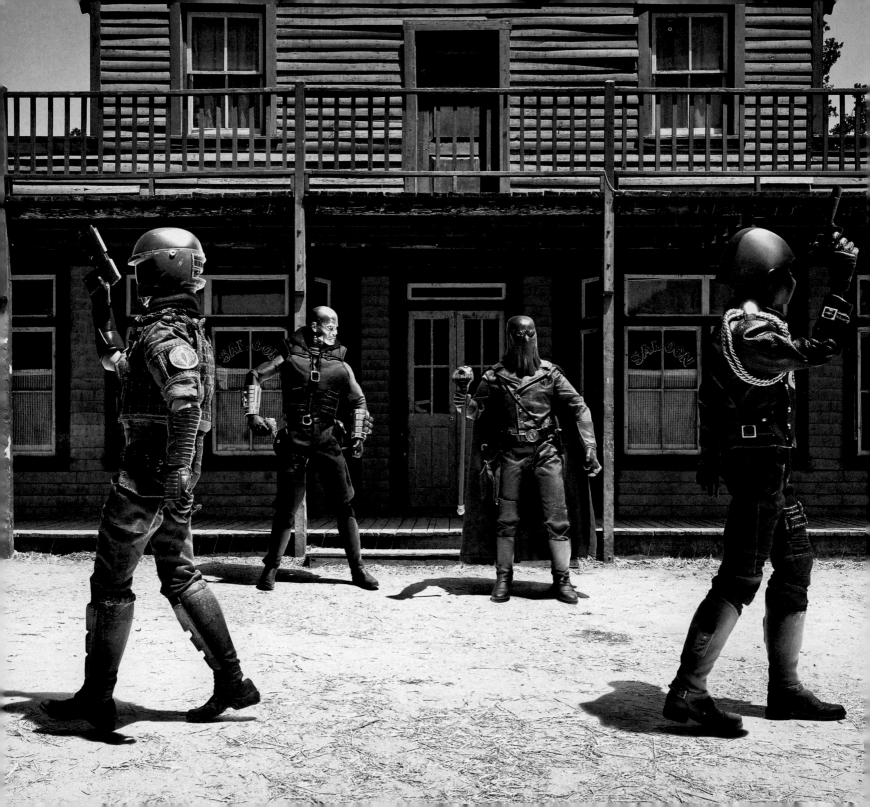

"The Paramount Ranch, located near the Agoura Hills suburb of Los Angeles, was a popular movie location in the 1930s. I originally shot this photo as a regular showdown scene but later reimagined it as a classic Western duel. You can see the Cobra guards engaged in the duel while Destro is plotting something in the background, reaching for his gun."

COBRA GUARDS ENGAGE IN A WESTERN DUEL.

AFTERWORD BY
KEVIN SMITH

I'm not ashamed to admit that, as a boy, I had lots of *dolls*.

The original G.I. Joe, the Mego Joker, the Six Million Dollar Man—these were flat-out dolls, no different from Barbie. But every once in a while, some half-in-the-bag uncle would call me out on what he saw as troubling with a boozy, "Why's this kid playin' with dolls?" Screw that: Having a Batman doll meant I could play Batman anywhere I wanted—especially while bored out of my mind at an inebriated relative's house.

But one day some marketing whiz stopped calling them dolls and started calling them *action figures*. So when someone would see my Princess Leia and mutter something about me playing with dolls, my mother would correct them, offering, "It's not a doll, it's an action figure." As an adult, I still have lots of action figures. But really, I still call 'em dolls, because dolls are for *boys* too. And *girls*. And *men*. And *women*.

It's those men and women who will truly appreciate this book, which is packed with more action (and figures) than any movie I've ever made. As children, we could mix and match our toys within their different universes, limited only by our imagination. At play in my youth, I could put *M.A.S.H.* dolls (yes, they had them) in the Millennium Falcon, and all it cost me was time. But if you wanted to do a literal *Star Wars M.A.S.H.*-up in real life, it'd be cost-prohibitively expensive, not to mention practically impossible.

That's what makes photographer Daniel Picard's salute to all the fun we had with our toys as kids so rewarding: It shows us things that normally couldn't exist. It takes some of our favorite characters and makes them as real as we did when at play with their totems, but it never presents what would be the real bill attached to undertaking such an endeavor with actual human beings. Since Sideshow Collectibles makes such photo-realistic, lifelike-looking replicas, who needs people?

If you played with dolls as much as I did, you probably made this book a thousand times on your own without ever actually snapping a picture. And after years of making snow angels with my Snowtrooper doll as a kid, one look at the stunning, hysterical photographs in this comedic (and artistic) collection is like a time machine back to a simpler age.

WHAT SNOWTROOPERS DO ON SUNDAYS IN THE WINTER.

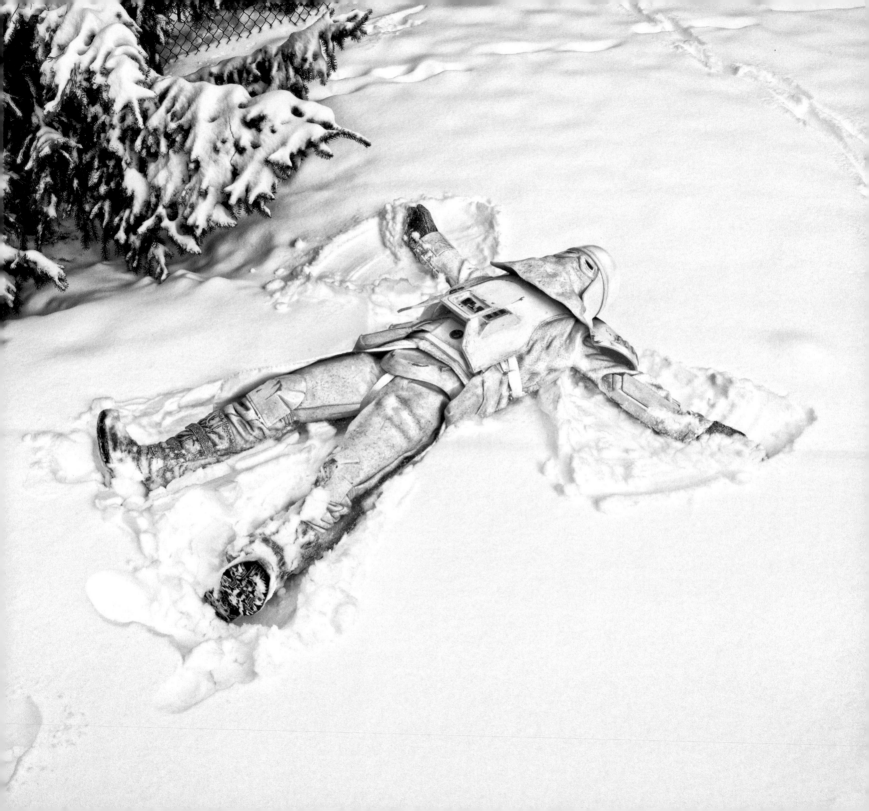

ACKNOWLEDGMENTS

I would like to say a very big thank you to everyone who has made this book possible: The Sideshow Collectibles team, whose amazing artistic work inspires me every day. Greg Anzalone, for believing in me and for introducing me to Insight Editions; without you, this book would still be in my head. The team at Insight Editions, for their hard work and for making this book a reality. My good friend Serge, for all of his encouragement and help during our photo shoots. My parents, for giving me the "creative gene." Finally, my wife, Marianne, and my very cool daughter, Alexia, for their love and support. I enjoy bouncing ideas off of them and watching their reactions to new photos. Oh, and they love collectibles as much as I do!

ABOUT THE PHOTOGRAPHER

Daniel Picard is a graphic designer, photographer, and fan of all things pop culture. Working in the advertising industry for over fifteen years has allowed him to be creative and master his digital retouching skills. He picked up his first camera after learning that he was going to be a father. For his ongoing project *Figure Fantasy*, Daniel combines his love of collectible figures and statues with his passion for photography into a seamless art form to be enjoyed by people of all ages all over the world. His work has appeared on numerous websites, as well as in magazines and galleries. Daniel lives with his family in Ottawa, Canada.

Website: www.danielpicard.com
Email: dan@danielpicard.com
Facebook: Daniel Picard Photography
Twitter: @DanPicardPhotos

A STORMTROOPER STANDS GUARD ON
THE PORCH OF AN ABANDONED HOME.

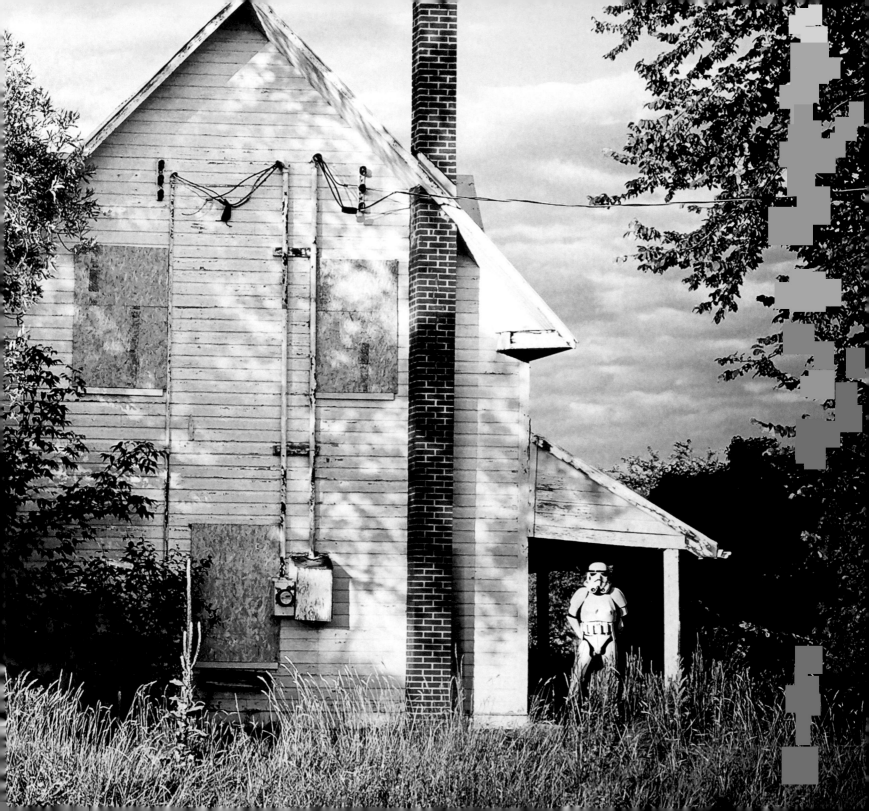

INSIGHT EDITIONS

PO Box 3088
San Rafael, CA 94912
www.insighteditions.com

Find us on Facebook: www.facebook.com/InsightEditions
Follow us on Twitter: @insighteditions

Library of Congress Cataloging-in-Publication Data available.

ISBN: 978-1-60887-551-1

Publisher: Raoul Goff
Co-publisher: Michael Madden
Art Director: Chrissy Kwasnik
Book Layout: Leah Bloise
Executive Editor: Vanessa Lopez
Senior Editor: Ramin Zahed
Production Editor: Elaine Ou
Editorial Assistant: Kathryn DeSandro
Production Manager: Lina sp Temena
Production Assistant: Sam Taylor

ROOTS of PEACE REPLANTED PAPER

Insight Editions, in association with Roots of Peace, will plant two trees for each tree used in the manufacturing of this book. Roots of Peace is an internationally renowned humanitarian organization dedicated to eradicating land mines worldwide and converting war-torn lands into productive farms and wildlife habitats. Roots of Peace will plant two million fruit and nut trees in Afghanistan and provide farmers there with the skills and support necessary for sustainable land use.

Manufactured in China by Insight Editions

10 9 8 7 6 5 4 3 2 1

CAPTIONS FOR PHOTOGRAPHS APPEARING ON PAGES 1–8:

PAGE 2: DARTH VADER AND HIS STORMTROOPERS INVADE THE SIDESHOW COLLECTIBLES LOBBY.

PAGES 4–5: BATMAN KICKS DOWN THE DOOR OF AN ABANDONED PRISON.

PAGE 7: A FACE-OFF BETWEEN SHAUN (*SHAUN OF THE DEAD*) AND JASON (*FRIDAY THE 13TH*).

PAGE 8: THE PHOTOGRAPHER POSES WITH A FEW OF HIS CLOSE FRIENDS AT AN ABANDONED FARM NEAR OTTAWA.

SIDESHOW.

2630 Conejo Spectrum Street
Thousand Oaks, CA 91320
www.sideshow.com